The Fair-Line and the Good Frontage

Stephen Walker

The Fair-Line and the Good Frontage

Surface and Effect

palgrave
macmillan

Stephen Walker
University of Manchester
Sheffield, UK

ISBN 978-981-10-7973-3 ISBN 978-981-10-7974-0 (eBook)
https://doi.org/10.1007/978-981-10-7974-0

Library of Congress Control Number: 2018932367

This Palgrave Macmillan imprint is published by Springer Nature
The registered company is Springer Nature Singapore Pte Ltd.
The registered company address is: 152 Beach Road, #21-01/04 Gateway East, Singapore 189721, Singapore

To travelling showpeople.

PREFACE

This book offers an extended consideration of the fairground showfront, a subject that is virtually undocumented beyond the fairground enthusiast community. It brings the showfront alongside architectural theories of surface, which in turn have been influenced by philosophical work on aesthetics and the perception of surface, in order to develop a discussion about the space-making effects at work in the fairground.

Arguably, architecture and architects are always interested in surface, although the direction and pitch of this interest ebbs and flows. At the present moment, we are witnessing a renewed vigour in such discussions, prompted in large part by the rapid developments in material science, fabrication techniques and construction practices, as well as the impact on architectural design processes and practices brought by computational power, integrated software and architectural education.

Despite the various flavours that are available in these discussions, many architectural writers are reaching back to the nineteenth-century work of Gottfried Semper and particularly to 'The Four Elements of Architecture: A Contribution to the Comparative Study of Architecture' (1851). This book is no exception. However, it does offer a sustained consideration of Semper's work on the origin of architectural 'enclosure'—which Semper identified with woven mats and carpets—bringing this into contact with another example of a woven cloth: that which fronted the original fairground attractions as these developed around the time that Semper was working. As Semper himself admitted regarding his origin theory of architecture, 'This [assertion] may appear strange and requires an explanation.' By offering a sustained engagement with the evolution of these two cloth frontages, this book will

provide 'an explanation' for this strange conjunction, as well as for the continuing relevance of some of Semper's theories in a new context. Indeed, on closer inspection, the historical repertoire of the fairground showfront offers a range of surprising parallels with the changing conceptions of architecture's surface. It can also be seen that both of these surfaces have complex relationships to the origin myths of their respective professions.

Semper's assertion was that architecture's enclosure and space-making or space-effecting qualities began, and continue to begin, with the surface. This goes against much received architectural wisdom, which has surface as the final and often least important element in a practice that prioritizes structure and tectonics. Consequently, the direction of a Semperian analysis tends to move outwards from the surface, and to pay less (or no) attention to interiors, to good form, or to structure. This outward move resonates with other recent interests in networked relationships and promotes an understanding of architecture that situates it as part of an expanded field of endeavour and production rather than as an isolated, independent object.

Considering other fields of endeavour, it is notable how the sustained architectural theorization of surfaces, as well as architectural metaphors of surface, is frequently drawn on by academics writing on a range of other topics and from a range of other disciplines. Recent examples of this trend can be identified across modern languages and cultures, cultural and urban geographies and histories, philosophy, cultural studies and cultural theory, post-human media studies, design studies and experience design, urban studies and theory and so on. Such exchanges are not always straightforward and sometimes suffer from losses in interdisciplinary translation. Architectural theorist Mark Wigley has observed how cultural critics within and outside architecture have previously been hoodwinked by the powerful visual and written mediation of the surface image of modern architecture that the discipline—or rather, those who speak for it—wanted to propagate. Equally, architectural practice and theory has its own long history of borrowing widely, and often imprecisely, from other disciplines, an activity I will perpetuate here in both breadth and imprecision.

Coincidentally perhaps, one of the principal processes discussed in the book concerns the various kinds of mistranslation or misinformation that the showfront supports. Important here too, though, is my contention that the articulation of these and other surface effects, and their space-making or space-effecting qualities, can be pursued by considering the showfront, and in particular the composite arrangement of showfronts that form the boundary to the fairground, through the lens of architectural theory. In addition to the work of Semper, I draw particularly on the

work of two philosophers of surface: Avrum Stroll and Andrew Benjamin. In complementary, and sometimes opposing ways, Stroll and Benjamin provide support for the wide-ranging considerations of the intentions and encounters with surface that are available in the fairground.

Important here also is the question of atmosphere; the fair as an environment, as an event, thrives on atmosphere and crowds. Consequently, the text will also engage with recent interest in affect theory, with the affective turn taken by several of the academic disciplines already mentioned and particularly with the philosophical work on the aesthetics of atmosphere developed by Gernot Böhme. Despite the thoroughgoing ambiguity that accompanies attempts to discuss atmosphere (or perhaps because of this), it is notable that debates concerning this issue are once again being taken seriously by architects, urban designers and cultural geographers, who are asking whether affect, or whether atmosphere, can be designed, controlled or manipulated to particular ends.

Concerning the core objects of my study, there are few books available on fairground art and architecture. Two significant exceptions are David Braithwaite's *Fairground Architecture* (1968), which provides the only sustained engagement with fairgrounds from an architectural perspective. Geoff Weedon and Richard Ward's *Fairground Art* (1981) is the best survey of the decorative arts on fairground rides and attractions. Both these books are currently out of print. It is across, rather than into, this sparsely occupied territory that the present work moves. It combines archival material (particularly from the 'Orton and Spooner' and 'Braithwaite' collections held at the National Fairground and Circus Archive in Sheffield, England), contemporary examples of fairs and a sustained theoretical engagement with influential philosophies of surface already noted. Initial chapters introduce these philosophies, the material, constructional, representational and decorative evolution of showfronts, and the processes by which individual fairground rides and attractions are arranged to form an enclosing boundary for the whole fair. Later chapters focus on issues of spectacle and illusion, the vast 'interior' spaces of the fairground, and on atmosphere, crowds and surface effects. Informed throughout by a wide range of work from the other fields already mentioned, this book will be of interest to readers in these areas, as well as those with an interest in architecture and those more generally curious about the fairground.

Sheffield, UK Stephen Walker
October 2017

ACKNOWLEDGEMENTS

I would like to express my thanks to colleagues and PhD students at The Manchester School of Architecture, who heard a much earlier version of this text as work very much in progress and were generous and honest in their discussion and comments: Richard Brook, Eamonn Canniffe, Debapriya Chakrabarti, Angela Connelly, Luca Csepely-Knorr, Isabelle Doucet, Sabine Hansmann, Alan Lewis, Ray Lucas, Leandro Minuchin, Brett Mommersteeg, Raqib Abu Salia, Fadi Shayya, Łukasz Stanek, Léa-Catherine Szacka, Garrett Wolf, Albena Yaneva and Stylianos Zavos.

To the staff of the National Fairground and Circus Archive for their warm welcome, patience with my endless archival requests and more recent patience and persistence chasing and processing the bulk of the images in this book: Arantza Barrutia-Wood, Angela Haighton, Anthony Hughes, Andrew Moore and Matthew Neill.

To Graham Downie, Anthony Harris, Vanessa Toulmin and Ian Trowell for their constant help, advice and insight into the history and contemporary practices of the travelling fair.

To Andrew Benjamin, Mark Dorrian and Maria Mitsoula for the various forms of impact their work has had on my thinking about surfaces and other things.

For their help and patience identifying images and resolving copyright and reproduction rights: at Erewash Borough Council, Helena Richardson (Events Officer) and Stewart Millar (Communications and Culture Manager); at Tewkesbury Borough Council, Samantha Hammond (Communications Officer) and Rose Gemmell (Solicitor); and Andrew Rimmington at the Leeds and District Traction Engine Club.

At Palgrave, I would like to thank Joanna O'Neill and Joshua Pitt for their encouragement and support through the various stages of this book's development and production, as well as the anonymous peer reviewers, whose comments and observations were precise, challenging and timely.

And at home, to Julia, Felix and Benjamin.

CONTENTS

List of Figures

Intro: Bostock and the Good Frontage

Abstract This chapter introduces the main protagonists: the showman Edward Henry Bostock (1858–1940) and two philosophers of surface, Avrum Stroll (1921–2013) and Andrew Benjamin (1952–). It also introduces the importance that Bostock attached to the 'good frontage,' the central philosophical ideas concerning surface effects and their space-making qualities, and the relationship that these have with historical and contemporary architectural and cultural theory.

Keywords Frontage • Fairground architecture • Surface effect • Semper

Reflecting on his life as a showman, Edward Henry Bostock (1858–1940) recounts how 'I decided that the first essential to success was a good frontage, and resolved to do the best with the show afterwards. And I found this policy paid' (Bostock 1927, 94). Bostock was an internationally well-known and hugely successful showman, part of the Bostock and Wombwell dynasty who were initially famous for their Victorian menageries, later diversifying into circuses and theatres on both sides of the Atlantic. His confession that what's behind the frontage was something of an after-thought that matters less than the facade guides the investigation in this book, which is less concerned with what goes on in the show, and focuses instead on issues relating to the 'good frontage' (Fig. 1.1).

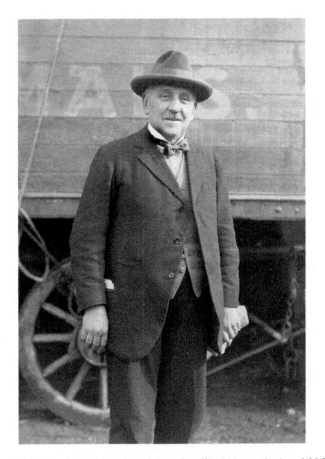

Fig. 1.1 Mr Bostock of Bostock and Wombwell's *Menagerie* circa 1913 (David Braithwaite Collection from the William Keating Collection. Reproduced with permission from the University of Sheffield Library, National Fairground and Circus Archive)

The notion of presenting a good front is relevant for any business in its attempts to appeal to prospective customers or clients. Indeed, Bostock's mantra is taken from an autobiographical account of the break he made, in September 1881, with his 'mother and the dear old show, in order to start out with a small menagerie of my own,' which he justifies because he perceived his 'parents' menagerie had suffered, from lack of an attractive front' (Bostock 1927, 94),[1] and had thus failed to attract customers. In an increasingly networked world, the ingredients that contribute to this

impression have become more varied in kind. For the showman, however, the issue of having a good frontage was, and remains, a physically localized concern (although the symbolic referents that decorate these frontages now circulate in a market with global visual reach). Amplifying certain aspects of Bostock's remarks, the notion of a front can also carry connotations of untruthfulness, either because the claims made on the front are not delivered by the business concerned, or because the frontage is set up as a distraction behind which something else (usually illegal) is being carried out: the business is a front for something, or in other boundary terminology, it is a 'fence.'

Although the 'good frontage' was—and remains—of major importance to individual showmen, this book will pay as much attention to the collective frontage of the fairground, particularly where this operates to define and enclose the fair, to separate if off from its surroundings (Fig. 1.2). In the UK, fairs set up for just a few days in the centre of villages, towns and cities, in streets and on market places, in car parks and wide boulevards. Fairs also set up on green field sites on the edge of town. In all these situations, the

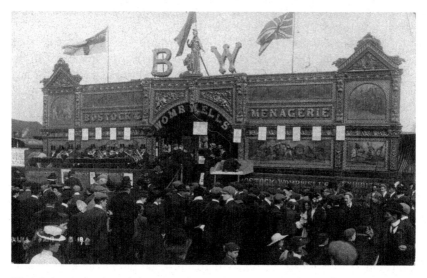

Fig. 1.2 Bostock and Wombwell's *Menagerie*, Hull Fair, circa 1906 (David Braithwaite Collection from the William Keating Collection. Reproduced with permission from the University of Sheffield Library, National Fairground and Circus Archive)

separation between the fair and the world outside is organized along what is known as the 'fair-line,' which will be introduced fully in Chap. 2.

In this book, I mobilize some recent (and some not so recent) architectural considerations of surface to address the operation of the fair-line as both an organizer and generator of space. I will sidestep the more extensive arguments about whether the fair should be considered to be architecture.[2] Commonly, architectural projects are likened to fairgrounds when they are being criticized. For example, Angelica Trachana is down on 'architects like [Frank] Gehry and [Enric] Miralles' for producing 'frivolous, fairground stuff'[3]; English Heritage Chairman Sir Jocelyn Stevens damned Will Alsop's proposal for Bloomsbury Square in London for 'turn[ing] it into a kind of matchstick fairground'[4]; and Sebastian Redecke reports on plans to revisit an unbuilt 1930 project by Ludwig Mies van der Rohe with the title 'Wir wollen keine Kirmes veranstalten' ['We don't want to organise some kind of fairground'] (Redecke 2013). The broader attitudes behind these criticisms will come into play at various points in the main text, revealing perhaps that the fairground, along with other temporary 'architectures' and highly decorated facades, indicates a certain return of the repressed into the delicate constitution of architecture. This simplified binary will be challenged in passing.

More important here, though, is my contention that the articulation of surface effects and their space-making or space-effecting qualities can be pursued by considering the fair-line, and the 'good frontages' that it organizes, through the lens of architectural theory. Moreover, I suggest that this particular example of space-making practice can engage and extend architectural theory. On closer inspection, the historical repertoire of the fair's surface, Bostock's 'good frontage,' offers a range of surprising parallels with the changing conceptions of architecture's surface. In Chap. 4, the material, constructional, representational and decorative evolution of the 'good frontage' will be introduced, and these parallels will be indicated in more detail. There, it can also be seen that both surfaces have complex relationships to the origin myths of their respective professions.

The contributions of architectural theory will be read in conjunction with the work of two philosophers of surface, Avrum Stroll and Andrew Benjamin. The rationale for this potentially antagonistic combination will be set out in Chap. 3. Benjamin's 'theoretical history' and Stroll's 'direct realism' approach the questions of surface with very different, possibly opposing, concerns and agendas. My intention here is not to try and reconcile them but to bring them into contact with the example of the fair-line,

with Bostock's 'good frontage,' in ways that challenge and extend our understanding of its operation. Stroll pays attention to 'the commonsense notion of a surface,' to 'folk physics or folk semantics' (Stroll 1988, 11)[5]: he is particularly concerned with how 'we' perceive and define a surface, and his writings raise questions that architects and architectural historians should not shy away from. Nevertheless, with the case of the fairground, and the 'good frontage' in particular, some aspects of Stroll's questioning concerning the relationship between surface and depth must be suspended.

In direct contrast to Stroll's advocacy of 'a non-theoretical descriptivist' approach, Andrew Benjamin's contact with surface is to explicitly (re)engage moments from architectural history. Influenced by his namesake Walter Benjamin, he puts fragments of the past to work as a constellation, assembled and interrogated in response to new relationships that emerge from contemporary concerns. In his essay 'Surface Effects,' Andrew Benjamin explains how this involves 'theoretical history.' 'What occasions the introduction of theory is the presence of a space opened by a relationship whose formal presence cannot be determined in advance' (Benjamin 2006, 2). In the spirit of Benjamin's theoretical history then, this book introduces architectural theory into the space—or the descriptive gap—opened up when faced with the 'good frontage.'

On a more prosaic historical note, the book will operate within a period that begins, approximately, in the middle of the nineteenth century and continues through to the present day. Again, the rationale and justification for this is set out in Chap. 4, and is closely linked to changing material practices on the fairground. Although fairs have a much longer history, operating for many hundreds if not thousands of years, their purpose, constituency, organization and control have changed significantly over this longer history. (Moreover, there is very little extant material with which to work in any detail earlier than the mid-to-late nineteenth century.) For reasons that will become apparent, this story follows certain material and technological developments that, while specific to the fairground, have strong parallels to broader technological, socio-cultural, architectural and urban changes that were felt across all societies within the Western world. The fairground was, and remains, an environment within which novel experiences have been offered by showmen and taken up by a curious public. Although the variety of these are beyond the scope of this book, one aspect of my main concern with surface effect will acknowledge the changing modes and organization of perception that occurred during this same period. Jonathan Crary's work engages these issues through a far

broader range of instances and examples, although his interest coincides comfortably enough with the mid-nineteenth-century emergence, the development and culmination (at least in terms of material, labour and size) of the good frontage in the early part of the twentieth century. Crary's analysis of human perception, individual and collective looking, prompts questions concerning the operation of the good frontage that are taken up in different directions in Chaps. 5 and 6. The role of the surface is discussed there in terms of its involvement in the establishment and disruption of space (both architectural and relating to individual and group identity), and the theoretical challenges that emerge as a result. Important within Crary's argument is his assertion that classical conceptions of space and self, and the clear bounding role played by surface therein, no longer hold in the modern world. In particular, he describes how 'The disintegration of an indisputable distinction between interior and exterior becomes a condition for the emergence of spectacular modernizing culture and for a dramatic expansion of the possibilities of aesthetic experience. The relocation of perception ... in the thickness of the body was a precondition for the instrumentalising of human vision as a component of machinic arrangements' (Crary 2001, 12–13). While the changing visual attractions of the fairground can be easily understood to be linked closely to the development of these broader machinic arrangements and associated aesthetic experience (in the fuller bodily sense), analysis of the role and impact of the good frontage, and the challenges or support this brings to theories of the architectural surface, is less straightforward.

In addition to the changing conceptions of surface and self that can be linked to such material and technical changes, attention towards more metaphorical surfaces can also be indicative of shifts taking place in social and artistic attitudes. In her study of the post-war developments in French culture, Kristin Ross describes a great yearning (or *fringale*, after Roland Barthes) for metaphorical and visible cleanliness witnessed in France as the country attempted to 'cleanse itself' of wartime and colonial 'dirt' and 'stains.' In sympathy with this collective conscience-cleansing, Ross identifies parallels occurring within various forms of cultural production, which were required similarly to 'cleanse' themselves of the constraints of previous approaches. Addressing the *nouveau roman*'s abandonment of systematic romanticism, she argues that 'All projections of depth—which is to say, of human significance—must be eliminated in order to arrive at the picture of a world that is "neither significant nor absurd. It *is*, quite simply. Around us ... things are *there*. Their surfaces are distinct and smooth, intact."

The cleansing process must be thorough ... When this fundamental cleansing of figurative language has been accomplished, then "the world around us turns back into a smooth surface, without signification, without soul, without values, on which we no longer have any purchase": a world of desire without values' (Ross 1994, 76–7).[6]

With earlier roots (but arguably with greater endurance), a similar connection is frequently made between modern architecture's demands for a 'clean' white surface. While these will be discussed in more detail in the main text, particularly in Chap. 4, the parallels with the *nouveau roman* or modern novel are worth pointing out here. Whether this express desire for a smooth surface is understood (physically) as a rejection of the excesses of Victorian and Edwardian decoration (indeed, the decoration that characterized Bostock's own good frontage and its heirs) or (more metaphorically) as a revaluation or even a devaluation of how surface communicates meaning, the over-determined, changing capacities and demands of surface effect can at least be hinted at. Despite this over-determination and concomitant with its surface cleansing, Ben Pell has noted a historical trajectory that saw modern architecture shift away from an interest in surface towards a growing concern with space, with consequences for the communicative role of surface. 'In losing its status, the architectural surface was stripped of its significance as a site of engagement ... Ornament and decoration were instead recast as excesses *on* rather than *of* the surface' (Pell 2010, 8). Gottfried Semper, whose architectural theory will be taken up more and more as this book progresses, would challenge this suggestion fundamentally. For Semper, architecture began with ornamented and decorated surfaces, and although these necessarily change over time, it was at the surface that architectural engagement remained significant. In no way would Semper concede ornament or decoration to be excessive: instead, their emergence and evolution constitute one of the core elements of architecture, product and productive of the surface itself.

There is another mode of cleaning that can be witnessed in more recent architectural concerns with the smooth surface, with striking echoes of Robbe-Grillet's demands for the *nouveau roman* and the elimination of human significance. In contrast to the physically flat smoothness of modern architecture's white walls, the champions of this new architecture describe its smoothness as akin to the 'devaluation of language as a means of expression and representation within global capitalism,' describing how this shifts the architectural surface 'away from language and signification, grammar, or syntactical and semantic values' and towards 'the production

of affects, an uncoded, prelinguistic form of identity' (Zaera-Polo 2009, 111, 114).[7] Under this rubric, architectural surfaces have witnessed a resurgence of ornament and decoration, characterized in particular by the new design and fabrication capacities of digital technologies, and underwritten by an association with post-critical thinking and neo-liberal worldviews. The new mode of engagement with these surfaces, as Douglas Spencer's acerbic critique notes, is reduced to the 'enjoyment of immediacy' (Spencer 2016, 152), freed from human significance, from meaning. A proponent of this post-critical smoothness, Lars Spuybroek again damns '"meaning"—that horrible word that lets us believe the mind can trade aesthetics for textual interpretation' (Spuybroek 2011, 86). Spuybroek's book is an explicit engagement with, or more precisely a redeployment of, the writings of John Ruskin, a contemporary of Semper. Indeed, Spuybroek also engages with Semper's work at key moments in his argument in favour of a meaning-free celebration of (surface) construction. Such, perhaps, is the enduring ambiguity, flexibility or broad appeal of Semper.

Indeed, the conceit of this book is to bring together the good frontage of the fairground and Semperian interest in the surface. In so doing, it will rehearse a number of theoretical concerns that enjoy a long and often awkward engagement with architecture and with the production, dynamics and consumption of spatial effects. My focus on the good frontage inevitably comes at a cost. Following Bostock's advice, my approach has been to stay 'in front,' rather than entering into the shows themselves and enjoying their multiple delights. Similarly, I do not stray far away from the frontages along the fair's boundary, again missing out on the multitude of other architectures, surfaces and experiences on offer within the crush at the centre, or centres, of the fair. I hope to *do my best with the show afterwards*.[8] Before any of these discussions can be undertaken though, the fair-line has to be introduced more fully.

NOTES

1. In this same passage, he describes how he commissioned his 'good frontage': 'amongst other features I had prepared was a very nice front entrance ... which was built to my own specification. I took delivery of my new front... towards the end of January 1883.' He goes on to describe how subsequently, and presumably following his example, his mother got a new entrance made 'from Burton on Trent' (Bostock 1927, 95). This was almost certainly made by Orton and Spooner, who will return at several moments in the account that follows.

2. David Braithwaite's 1968 book *Fairground Architecture* (Hugh Evelyn, London) provides the only sustained engagement with this potential connection. See also my own critical survey of (superficial) architectural interest in the fair: Walker (2015).

3. 'I'm fed up with this trend for architecture as spectacle. It's frivolous, fairground stuff, all form and no content, designed to make you stop and stare rather than put you at ease as a human being. Architects like Gehry and Miralles have forgotten the concept of urban space in their desire to create isolated objects of art that just make an impact' (Trachana 1998), relayed in Hellman (1998).

4. 'In the [recent press] release [English Heritage chairman Sir Jocelyn Stevens] is quoted as saying... "It took a quite distinguished listed building and completely and utterly mucked it up—the principal elevation is totally obscured by strange structures and the impact on Bloomsbury Square was to turn it into a kind of matchstick fairground"' (Taylor 1999, 7).

5. It is perhaps important to note here that Stroll is generally (and increasingly) upfront about his Wittgensteinian slant, trying to replace theorizing and explanation with *description* (urging 'the context-sensitive, example-oriented, descriptive approach to perception, following Wittgenstein' (Stroll 1992, 210). Indeed, earlier in this article, he describes J. J. Gibson's practice as that of 'a non-theoretical descriptivist' (204), something he admires and advocates. 'When Gibson confines himself to description his comments strike the mark... But when he begins to theorize his comments begin to lose their grip' (205).

6. Quoting Robbe-Grillet (1965, 19 & 40). Original emphases. For a fuller discussion, see Ross, Chap. 2, 'Hygiene and Modernization' (1994, 71–122). See also Adrian Forty (1986), for an analysis of 'the aesthetic of cleanliness,' its social, material and surface treatments, as this developed in the first third of the twentieth century particularly.

7. The editor describes this article as an expansion and exemplification of the author's four categories of the envelope introduced in Zaera-Polo (2008). Zaera-Polo makes a clear distinction between the surface and the envelope: 'The envelope is the surface and its attachments' (2008, 195).

8. A longer work, on the architectures, cultures and identities of the travelling fair, is in preparation.

CHAPTER 2

The Fair-Line

Abstract The 'fair-line' is a notional setting-out datum used by fair orga-
nizers to plan the locations of rides and attractions that make up the fair. This
chapter provides an introduction to the 'fair-line' as the outer boundary of
the travelling fair. It explains its histories, the drawings used in its planning
and implementation, the practicalities of installing rides and attractions
along this line and the consequences this arrangement has on the experi-
ence of the fair. Three key ingredients of this experience are discussed—
boundary, crowd and atmosphere—and their inter-relationships identified.
The complexities of these inter-relationships structure the main text in the
remainder of the book.

Keywords Frontage • Fairground architecture • Crowd • Atmosphere

The fair-line is a notional setting-out datum used by fair organizers to plan
the locations of rides and attractions that make up the fair. As Stroll sug-
gests in a more general context, what perhaps sounds straightforward
involves unanticipated complexities. 'It is plausible to think of a surface as a
boundary … What kind of boundary is a surface? More generally, what is a
boundary? Is it a kind of limit? … Is "line" a boundary word … ?' (Stroll
1988, 10–11). Several parties are involved in negotiations regarding the
planning of fairs, usually including representatives of the Showmen's Guild
of Great Britain (SGGB) and an agent of the local authority such as the

© The Author(s) 2018
S. Walker, *The Fair-Line and the Good Frontage,*
https://doi.org/10.1007/978-981-10-7974-0_2

Fairs and Markets Superintendent. It is usually the latter who is responsible for drawing up a layout plan that shows the fair-line, as well as for organizing the letting of positions and the collection of rent from stallholders. What is particularly interesting about these drawings, examples of which are illustrated in Figs. 2.1 and 2.2, is the way this overall organizational layout is generally determined by a line behind which there is no definite plan footprint: it is a line that simply locates the 'good frontages' of the rides and attractions. Figure 2.1 gives the plan of Ilkeston Charter Fair in 1965, which clearly shows the fair-line, behind which rides and attractions have no determinate depth. Many other instances follow the same convention. (On this particular drawing, the frontages of the buildings are also represented according to the same logic. Note in particular the partial representations

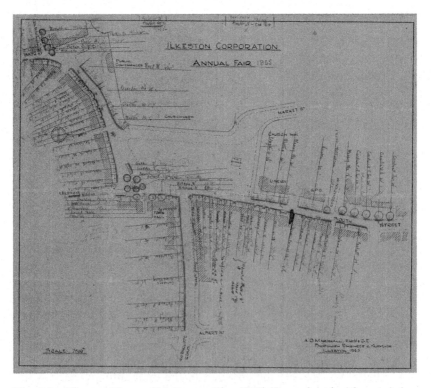

Fig. 2.1 Ilkeston Charter Fair Layout Plan 1965 (Reproduced with permission from Erewash Borough Council)

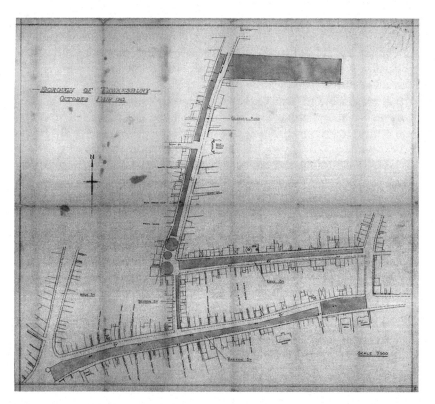

Fig. 2.2 The Plan of Tewkesbury Fair 1962 (Reproduced with permission from Tewkesbury Borough Council)

of significant public buildings that bound the site such as the Town Hall and (Carnegie) Library, which is only shown as a corner. The church building, which sits opposite the Town Hall, is not drawn at all.)[1]

Figure 2.2 shows the plan of Tewkesbury Fair 1962. At first glance this seems to indicate the depth of attractions more completely, but the setting-out dimensions again reinforce the observation that it was only the position of the fair-line, given with dimensions between this and the opposite kerb, that was of concern. That is to say, it was only the space in front of the fair-line that was controlled.

Reinforcing this conception, each position on the plan of Ilkeston Charter Fair is labelled with the name of the stallholder and the length of the stall frontage, information that was used by the Fairs and Markets

Superintendent to calculate rent for these positions (also annotated on the plan), a practice that determined the rental cost by linear foot of frontage, rather than by lettable area as happens with more conventional business properties. Today, most stall or ride owners still rent space by linear foot of frontage rather than by area.[2]

It is reasonable to assume that the drawing of the fair-line on layout plans such as these formalized a practice that had taken place for decades, even centuries, prior to the early twentieth century when such plans began to be produced.[3] Reflecting on their experience of the famous Oxford St. Giles' Fair during the nineteenth century, an anonymous contributor to *The Showman* of 31 August 1906 recalls how '[s]ixty years ago the shows were allowed to come into St Giles' Street at midnight Sunday, and as in those days there was no one to allot the ground, there used to be some pretty squabbles and the free fights for the best positions and it was generally daybreak when everyone had got comfortably—or uncomfortably—settled down' (Anon 1906).[4] Although this account draws out the petty squabbles that took place in the absence of the prior allocation of ground positions, very early photographs of the Oxford St. Giles' Fair show that despite these disputes, or when they were over and positions had been decided, the showmen had effectively self-organized their rides and attractions in an arrangement that clearly complies with the notional fair-line datum (Fig 2.3).

The emergence of layout plans was a consequence of the changes that took place in the early twentieth century as the SGGB and local authorities separately and together developed procedures to formalize site allocation and 'established rights' to particular sites.[5] The drafting of such plans has increasingly involved a layer of Health and Safety Executive (HSE) legislation that determines the widths of access, emergency escape distances, distances of separation between adjacent rides or between rides and adjacent buildings or obstructions and so on.[6] Today, although practices vary, the fair layout plans produced by local authorities almost always indicate the area or even the footprint of rides and attractions, as well as much fuller information about other aspects of the fair including temporary toilets, St. John's Ambulance positions, the fair superintendent's office, fire access and so on: nevertheless, the clear conception of the fair-line remains in these drawings. Once the fair-line has been established on the plan, it is then marked out on site by the Fairs and Markets Superintendent in the days prior to the fair's arrival, actually (re)drawn on the roads or grass where it will be set up (Figs. 2.4 and 2.5).

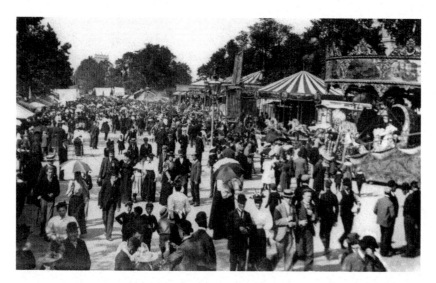

Fig. 2.3 Oxford St Giles' Fair, general view 1896 (David Braithwaite Collection from the William Keating Collection. Reproduced with permission from the University of Sheffield Library, National Fairground and Circus Archive)

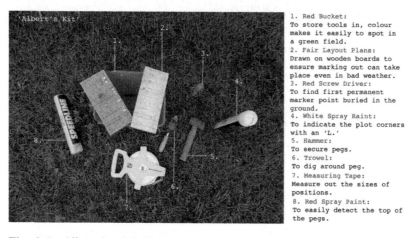

Fig. 2.4 Albert Austin's kit (Surveyor to the Fair, 1988–93) Newcastle Town Moor Hoppings 2012 (Annotated photograph, Ella Bridgeford and Stephen Walker)

Fig. 2.5 Oxford St. Giles' Fair 2013, showing fair-line marked out in green by Fair's Superintendent Mark Newman (Photograph, Stephen Walker)

When the individual rides and attractions begin to build up on their allocated position, the simple clarity of the line on plan is disrupted, returning us to the complex relationships that Stroll set out between line, limit, boundary and surface. This build-up provides many instances where the reality of the fair arrangement departs from the clear bounding surface suggested by the fair-line. The latter doesn't acknowledge physical obstacles such as lampposts, signs, bollards or other street furniture, nor does it anticipate trees and other overhead surprises. Figure 2.6, for example, shows H P Studt's electric track being built up around trees and bus stops on Oxford St. Giles' Fair on 4 September 1960.

The drawing of the fair-line on plan does not appear to concern itself with the actual footprint of rides and attractions, nor with their headroom, although clearly those involved have enough experience and cooperation to keep these dimensions in mind during the planning process: when the rides build up, their own individual 'good frontages' do not all coincide completely with the fair-line as this was projected. The fair's component

Fig. 2.6 H P Studt's *Monte Carlo* electric track being built up around trees and bus stops, Oxford St. Giles' Fair, 4 September 1960 (Jack Leeson Collection. Reproduced with permission from the University of Sheffield Library, National Fairground and Circus Archive)

parts fail to occupy continuously the fair-line. What is clearly conceived as a boundary, legible as the fair-line on the layout plan, is actualized as a heterogeneous surface, physically discontinuous but perceptually coherent. Different bits belong to differing typologies and the 'outside' intrudes, but there is something about the nature of this complex, compound surface that is very accommodating. More precisely perhaps, there is something about our perception and experience of, and interaction with, this surface that is very forgiving. Considering the space-effecting operations anticipated by surfaces recorded on the architectural plan, Benjamin argues that the logic of the plan must be understood to exceed a simple classification as an autonomous representation, that is to say, simply having its own rules, an 'internal regulation' (Benjamin 2008, 19), to be more clearly tied in to the architectural possibilities of the system it represents. The examples of the flexible actualization of the fair's boundary surface just given demonstrate something of this tie, such that the mute plan, in combination with the knowledge and know-how of the showmen, enables the operation of that surface's logic and effect, despite the apparent contradictions, irregularities and conflicts that are written into the plan qua autonomous, internally regulated document. Indeed, this flexibility of actualization, coupled with Benjamin's philosophical promotion of a plan-based surface logic, runs counter to the remit and expectations of control usually assumed by architects. Mark Wigley sketches out the frustrations and denials he perceives to exist within most architectural discourse and practice: 'Architects routinely deny that they are experts in producing effects. There is a general disdain for effect … The abstract line on the blank paper is supposed to be without atmosphere … When atmosphere returns, it is meant to be subordinate to reason, controlled by the line' (Wigley 1998, 25–6).[7]

The fair-line is arguably just one of several boundaries that the fair enjoys. Others occur at larger and smaller scales, and operate through different media. For example, we could map a strict legal limit boundary determined by the extent of approved road closures—limits which are rarely touched but which are available if extra space is needed within the fair for any reason—or we could map out the moving boundary of road closures, which vary during the course of the fair according to how much disruption the existing transport infrastructure can accommodate at any moment. Alternatively, we could map out other limit cases, such as that established by the noise of the fair, extending physically far beyond the fair-line. Despite these (and other) alternate boundaries or limits, the

arrangement of rides and attractions on the fair-line provides the most perceptible surface-boundary-limit of the fairground.[8]

As will be discussed in greater detail in Chap. 6, this boundary is often fairly permeable, with multiple larger or smaller ways in between rides; there is rarely or never a gate or official entrance. Once this boundary is crossed, the punter enters into the fairground environment, where the surface-boundary-limit operates to close the fair off from the outside world; it is like a lobster pot, offering stark differences in resistance depending on the direction of travel, easy to enter but hard to leave. From within, a punter can temporarily cross the fair-line by going beyond the frontage of particular rides and attractions, where they are enclosed within the *Ghost Train*, the *Waltzer*, the *House of Fun*, walk-ups and so on. (Some newer rides have no enclosure: on *Miamis*, for example, the activity takes place in front of a flat, highly decorated façade.) Nevertheless, this passage beyond the fair-line remains an experience *within* the fair: the good frontage maintains its control, while what is behind remains imperceptible, or more precisely remains without surface effect. It could be said that the frontage operates as a front without a back, and that the fairground environment it helps to bound and control aspires to autonomy.

Josie Kane has made a similar observation regarding the related constructions on fixed site amusement parts. In the caption to her illustration of Van der Decken's Haunted Cabin at Blackpool Pleasure Beach (1906), she notes that with its 'simple wooden structure with painted canvas or board frontage [it was] a decorative shed—long before they appeared on the Las Vegas strip' (Kane 2013, 129).[9] This allusion to Venturi and Scott Brown's well-known distinction between the duck and the decorated shed, from their studies of Las Vegas and elsewhere, is useful to follow at this point, as it introduces a further range of issues concerning how the surface or surfaces along the fair-line operate in terms of communication (Fig. 2.7).[10]

But arguably the fair-line is more ambiguous, as it gathers ducks and sheds. Moreover, it has a different relation to punters than the applied symbolic frontages of Vegas casinos, because of the immediate press of the crowd and because of the press of and interference between adjacent 'good frontages.' While these work collectively to form and maintain the lobster-pot operation of the fairground, once punters are inside, there is strong competition for their custom between rides. This enclosed spatiality is precisely what Venturi and Scott Brown were protesting against, as some of their opening remarks make clear: 'Architects have been bewitched

Fig. 2.7 Unidentified show under construction, circa 1900: rear and side views (Philip Swindlehurst Collection. Reproduced with permission from the University of Sheffield Library, National Fairground and Circus Archive)

by a single element of the Italian landscape: the piazza. Its traditional, pedestrian-scaled, and intricately enclosed space is easier to like than the spatial sprawl of Route 66 and Los Angeles. Architects have been brought up on Space, and enclosed space is easier to handle ... Purist architecture was a reaction against nineteenth-century eclecticism' (Venturi et al. 1977, 6–7). The fair-line organizes an eclectic array of 'good frontages,' although the scale of their arrangement is precisely that of the traditional, pedestrian-scaled and intricately enclosed space of the piazza (while lacking the sedate urbanity of the Italian hill town examples they nod to). The observations and values that *Learning From Las Vegas* sets out can open up analysis of the fairground, and the surfaces along the fair-line in particular; the latter also intensify the operation of the decorated shed frontage by crowding in on the punters (indeed, rides and attractions are often over-scaled for their host environments, adding to this affect) (Fig. 2.8).

This intensification has consequences for the particular dynamics of communication as they are set out in Venturi and Scott Brown's analysis, where they argue: 'This architecture of styles and signs is antispatial: it is an architecture of communication over space; communication dominates space as an element in the architecture and in the landscape' (Venturi et al. 1977, 8). Whereas the decorated sheds they had in mind were famously designed to be consumed at 30 mph, a look at the surface-boundary along the fair-line forces us to take issue with any generalized assertion that this

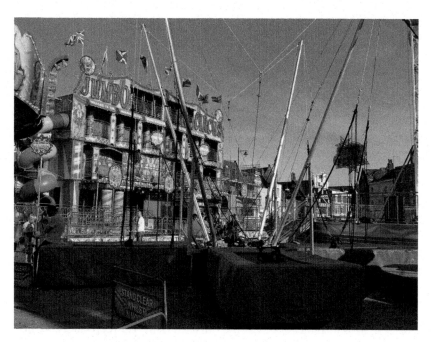

Fig. 2.8 Boston Fair 2016, showing the scale of the attractions, and particularly here the *Jumbo Circus*, overwhelming the historical Market Place in Boston, Lincolnshire (Photograph, Stephen Walker)

architecture is antispatial. Rather than the clear hierarchies of symbolic communication that they establish, even the visual assault of the good frontage overwhelms any notion of clear communication, an information overload that is compounded if we consider what is added by sound, taste and smell.

Robin Evans has remarked on potential consequences of such information overload: '…it is probably easier for us now to understand that information is not such an isotropically good and wholesome commodity as we might once have thought, and that immersion in a milieu of indiscriminate emblems, images, messages and ideas might just as easily discompose and confuse individuals and communities as enlighten them' (Evans [1971] 1997, 36). Although his comments were directed towards everyday life, the arena of the fairground bounded by the fair-line seems to present all of these things (but in contrast to Evans' underlying horror, punters visiting the fair

choose to submit themselves to this kind of experience). His broader, architectural concern is to meditate on how architectural enclosures—and particularly the wall—perform, amongst other things, as a filter of information: 'This article … will deal with a strange way in which human beings render their world inhabitable by circumscribing and forgetting about those parts of it that offend them' (Evans [1971] 1997, 36). In some ways here, the fair-line can be understood to support this action of circumscription, organizing a surface-boundary-limit that cuts off the outside world from the activities and spaces of the fair. As we have seen already, this boundary does not have to be perfectly formed—far from it—and many components from beyond can intrude without threatening the success of the fairground as a distinct environment. In some cases, the architecture of the surrounding area will be appropriated into the collective frontage of the fair, but even where this is attempted unsuccessfully, the general milieu of fairground information supports the active, temporary forgetting of the 'offensive' outside world and maintains the autonomy of the fair. As Benjamin argues, 'surface [should be] defined in terms of potentiality rather than simple literal presence' (Benjamin 2006, 4).

With some of these considerations in mind, I would like to return to Bostock, who was introduced at the outset. Figure 1.2 reproduced a photograph of Bostock and Wombwell's Menagerie, taken at Hull Fair in 1906, illustrating what Bostock meant by his notion of the 'good frontage.' In Fig. 2.9, we can see a more open view of Hull Fair in 1904 (Bostock and Wombwell's Menagerie can just be seen on the extreme right of this image) and from the same position in 2016, showing a number of attractions arranged along the fair-line, attractions whose frontages produce the heterogeneous surface-boundary-limit to the fairground introduced above. Before going on to analyse this surface in more detail, it is important to pause and note the three key elements of the fairground that are shown here. The first is the surface-boundary-limit itself, where large attractions or shows form a strong periphery to define and contain the limit of the fair and heighten the sensations within, to mark a separation between the fair and the everyday world beyond. Secondly, there is the crowd; and thirdly the atmosphere. This is not to suggest that experience at the fair can be generalized: just as the surface is composed of a heterogeneity of 'good frontages,' each with their own typology and relationship to the show concealed behind, and each with their own rhythm, noise, groups of punters, spectators and so on, so the experience of individuals and groups at the fair varies enormously. Despite the difference in

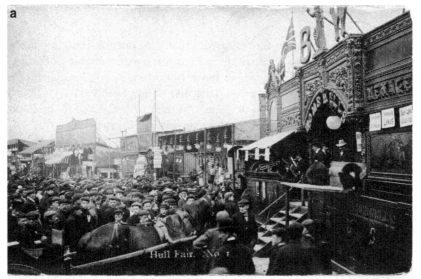

Fig. 2.9 (a) Hull Fair, General View with Bostock and Wombwell's Menagerie, 1904 (David Braithwaite Collection from the William Keating Collection. Reproduced with permission from the University of Sheffield Library, National Fairground and Circus Archive). (b) Hull Fair, General View from the same position as (a), 2016 (Photograph, Stephen Walker)

individual attractions, we can appreciate that they operate together along the fair-line to form an effective surface. At this particular scale of consideration, the fair taken as a whole has a boundary, it contains a crowd, and—when successful—it enjoys a particular atmosphere.

An anonymous, first-hand account of Oxford St. Giles' Fair in 1908 makes explicit the connection between these three elements:

> Round and about these attractions circled a multitude, somewhat smaller than last year—on Monday night at all events—but still big enough for pleasure and comfort. The crowd was like some great river clotted with matter, twisting and turning between its two banks as best it could. There was no coherent plan or purpose to its movements; the people simply swirled to and fro, eddying backwards and forward, up and down, across and along. (Anon 1908)

This quote is particularly telling, as it not only makes clear reference to the 'two banks' of attractions organized along the fair-line but also exemplifies the riverine metaphors that were used by many Victorian and Edwardian writers to depersonalize the individual in the crowd, to reduce or remove their human agency and replace this with the notion of the crowd as a force of nature (In *The Hunchback of Notre Dame*, Victor Hugo famously describes the crowd in the palace yard as being 'like a sea, into which five or six streets, like the mouths of so many rivers, disgorged their living streams. The waves of this sea, incessantly swelled by new arrivals, broke against the corners of the houses' (Hugo [1831] 2002, 6)[11]). Although much worrying has been done about crowds, especially by those witnessing the rapid growth of industrialization, urbanization and the potential this brought for mass assembly as the nineteenth century progressed, where riverine metaphors were more frequently used by writers worrying about 'the masses' or 'the mob,' the fairground crowd in most circumstances is very different to other (urban) crowds: it is neither motivated by a single cause (political protest, for example) nor does it present a particular threat to good order (although this was the nagging worry of Victorian moralizers). Moreover, Crary's work follows a parallel counter-development that arguably atomizes the large crowds historically associated with fairs and carnivals: he notes how the changes in the nature of attractions brought about by the emerging technologies of mechanical visualization and projection during the late nineteenth and early twentieth centuries turned 'the multifaceted festival participant … into an individualized and self-regulated spectator,' and brought about 'the relative separation of a viewer from a milieu of distraction and the detachment of an

image from a larger background' (Crary 2002, 9, 11). At the fair, the crowd is actually made up of smaller or larger groups, as well as individuals, all of different ages and with different reasons for going. Nor is the fairground crowd a static or stable presence, as people come and go when they please, and stay for shorter or longer periods. Cross and Walton have grasped the nature of this gathering in their work on *The Playful Crowd*. There, they draw attention to the distinct heterogeneity of the crowd at the fair or amusement park, in contradistinction to other crowded events: 'As sites of outdoor spectacle that invite crowds to interact with each other and with the sites themselves, to participate actively as well as to gaze and listen, to move, mingle, compete for attention and put the self on show, [pleasure parks] created crowds distinct from sports or staged entertainment spectators. Their pursuits were distinctly complex ... And, in their inherent structure as artificial, but relatively open environments, they created a flowing, even potentially promiscuous, crowd that required special efforts to regulate and control' (Cross and Walton 2005, 5).[12]

This fairground environment and the behaviour of the playful crowd therein provided an example that various contemporary sociologists were drawn towards, believing its separation from 'ordinary' life supported broader understanding of the 'modes of experiencing the social reality of modernity' (Frisby 1986, 61). Georg Simmel (1858–1918) referred to this kind of separation using the notion of the adventure, something which falls outside 'the continuity of everyday, routinized life.'[13] Like a visit to the fairground, the experience of adventure was 'more definitively circumscribed than other experiences' (Frisby 1986, 66). People's willing submission to experiences of speed and shock provided by the new, mechanized, fast-moving rides that had begun to emerge during the late nineteenth and early twentieth centuries was arguably less of a contrast to their everyday life than the close interaction with strangers, and the degree of physical intimacy, that the playful crowd brought about[14] (Fig. 2.10). These countered the accepted rules of social convention that held sway outside this adventure, and the contribution of the fair-line must be also be acknowledged as an important ingredient in this process, establishing and maintaining a delimited environment that supported the playful crowd's attainment of the circumscribed adventure. The witness to Oxford St. Giles' Fair saw the two banks as a container that could withstand the riverine push and pressure of the playful crowd, bounding and containing it. Whether these banks operate for the benefit of the crowd, intensifying their experience, or as protection for the host town, like a levee that contains a flash flood, or as both, will be explored further in Chap. 6.

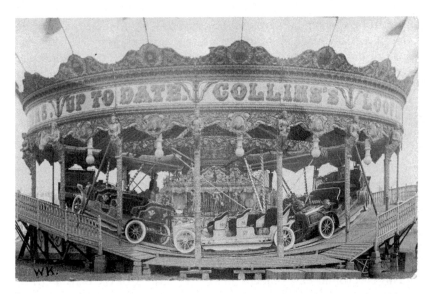

Fig. 2.10 Pat Collins' *Looping the Loop Motor Cars*, circa 1907 (David Braithwaite Collection from the William Keating Collection. Reproduced with permission from the University of Sheffield Library, National Fairground and Circus Archive)

The playful crowd gathers to enjoy the fairground atmosphere that they, in part, produce. Nothing attracts a crowd like a crowd, as the old wisdom goes, and an empty, yet operational, fairground provides a very different, uncanny experience. (See, e.g. Fig. 2.11, which was taken just prior to the official opening ceremony at Hull Fair in 2015.) Although much debate about atmosphere takes this to be intangible but affecting, fairground atmosphere is particularly visceral, product and productive of the crush of the crowd, cacophonous noise, the barrage of smells and tastes, direct or vicarious kinetic experience of mechanized rides. Angela Carter (1982) has argued that the crowd comes to the fair for this vivid, physical and immediate atmosphere: it is precisely not relaxing, not digni-fied (fun is not pleasure, not delight).[15] It is enjoyed (if this is enjoyment) in a strangely scaled environment inserted within, yet cut off from, famil-iar surroundings by the organization of the fair-line. Atmosphere is the glue that holds all this together, an energy produced in the paradoxical fusion-fission of the other ingredients introduced earlier, partly self-sus-taining, partly all-consuming. Although Carter argues that the fun of the

Fig. 2.11 Hull Fair, general view prior to the official opening of the fair, 9 September 2015 (Photograph, Stephen Walker)

funfair is fleeting and throwaway (like the food available there, it is 'not nourishing, not going to stay with you'), there clearly are aspects of the fair that are digested and that remain with punters very strongly. These can be rekindled as a sense of temporally and spatially localized anticipation—what we might think of as an atmosphere-to-come—related in part to the other boundaries noted above, but they can also develop more complex temporal depth, in the build-up to the arrival of the fair, and, with age, to people's memory of having gone to the fair earlier in their lives. Indeed, different stages of life carry strong, and markedly different, experiences and memories of the fair: for the young child (attending with parents or grandparents), for teenagers in large groups, for a parent or a grandparent. A related study by Tim Edensor on the Blackpool Illuminations sets out 'how the cumulative processes through which affect in place is experienced partly lies in its anticipation, adding to … critiques of the notion that affect is invariably precognitive. These depictions of reflective, historical, and

anticipatory engagements with place suggest that there is a thorough entangling of emotion and affect, an entangling that inheres in Gernot Böhme's notion of atmosphere' (Edensor 2012, 1105).[16]

According to Böhme's more general assertions, atmospheres are intermediate phenomena operating between subject and object, people and world. Böhme sidesteps the difficulties presented by the apparent vagueness or indeterminacy of the word when it is approached by a specialist discourse, arguing instead that its 'use in everyday speech ... is in many respects much more exact' (Böhme 1993, 113).[17] Here, I will follow the spirit of Böhme's general advice, and sidestep any attempt to set out a precise definition of the atmosphere of the architecture of the fairground for the time being. Accepting that the everyday understanding of 'atmosphere' is sufficiently exact, I want to return to Andrew Benjamin's work in order to open up a more detailed examination of the operation of the surface-boundary that is arranged along the fair-line. Benjamin makes an important assertion that connects atmosphere and surface: 'Atmosphere, the realm of affect, is not given by an enclosed space but one created by the operation of a surface' (2006, 28).[18] He offers a more expansive account of these dynamics slightly earlier in his text: 'The effects—the creation of affect—... come from the operation of material and forms. Effects are the work of surfaces that create spaces (rooms)' (2006, 24–5). The explicit replacement of enclosed space by the work of a surface is perhaps harder for architecture to stomach than it is for the fair. Fortunately here, my concern is with the fair-line, and how this organizes a surface whose work is to create affects or atmosphere.

NOTES

1. Note also that the base layer for this plan was drawn in 1945 by A O Marshall, the Borough Engineer and Surveyor, traced from a plan prepared in 1932 by his predecessor Geo. Smith AMICE, Boro Engineer: extant plans from 1947 to 1972 follow this graphic convention for the fair-line.
2. Prices are still generally charged in £ per foot or per five feet of frontage (not meters), depending on the size/value of the ride or stall. Major rides pay a fee per attraction.
3. Although fairs were subject to increasing levels of official control from the mid-Victorian era onwards, much of the early thrust of this control was directed at the individual and collective behaviour of those in the crowd,

with attempts to either clean up and moralize this, or to ban fairs completely (most famously with the *Fairs Act 1871*). Out of a related threat, the Showmen's Guild of Great Britain (SGGB) emerged effectively as a trade union for Showmen, who mobilized themselves in an act of self-preservation in the face of a threat posed by George Smith MP, who attempted to legislate the movements of all travelling people in his proposed *Moveable Dwellings Bill* (between 1884 and 1891). In response to this threat, showpeople joined together to form the *United Kingdom Van Dwellers Association* in 1889. The establishment or emergence of the SGGB is not fully clear, as in the last decade of the nineteenth and early years of the twentieth centuries, various organizations, or various names for the same organization, were in circulation, including the *United Kingdom Showmen and Van Dwellers' Protection Association (Showmen's Guild)* and *The British Roundabout Proprietors' and Showmen's Union*. The terms of reference and 'rules' of the Showmen's Guild were first drafted in 1902–03. For a fuller account of the establishment of the SGGB, see Thomas Murphy (1940 and c.1950).

4. This passage was shamelessly plagiarized by Father Greville in his historical account 'St. Giles Fair, Oxford' (Greville 1949).

5. The 'Established Right of Tenure at Fairs' is set out in the Rules of the SGGB and governs the conditions guaranteeing members of the Guilds certain continuity of rights over positions or ground at fairs.

6. This includes the pivotal Health and Safety at Work Act 1974 and the subsequent Home Office *Guide to Safety at Fairs*, 1976, and the *Code of Safe Practice at Fairs*, 1984.

7. Teyssot makes the same point from the opposite direction: 'Borders, frontiers and thresholds are not abstract lines... Rather, any limit or border has a mediating role that permits communication and allows for mutual passage' (Teyssot 2008, 12).

8. On the mapping of this particular limit, and the more complex ontologies of perception and cacophony they form part of, see the detailed work of Ian Trowell (2017a, b, 2018b).

9. Stefan Al has described the development of the Las Vegas frontage in terms that resonate with Bostock's mantra: 'the first architecture of the [Las Vegas] Strip embodied its dominant design philosophy: build a false front, as long as it is a spectacular one' (Al 2017, 25).

10. See in particular Part II, 'Ugly and Ordinary Architecture, or the Decorated Shed' in Venturi et al. (1977). The duck has overall symbolic form, while the decorated shed distinguishes between space and structure (programme), and ornament, which is separate, applied symbol. They acknowledge that this is not a black and white distinction: Chartres Cathedral is both a duck and a decorated shed. As with architecture, so with fairground rides.

11. For a broader discussion of this watery comparison, see Schnapp (2006) where he surveys the dominance of the 'oceanic' symbolism that runs through writings on the crowd, as well as the influence of panoramic photography on the enlargement of this mode of thinking during the first half of the twentieth century.

12. In a parallel observation, Josie Kane has noted how 'The visitor experienced the [Edwardian amusement] park as an ensemble landscape of commodified pleasures, infused with speed: multi-directional crowd flows, the movement of ride machinery, and the body itself in motion' (Kane 2013, 204).

13. Frisby (1986, 65), referring to Simmel's, 'The Philosophy of Adventure,' 1910, and subsequently, with minor changes, 'The Adventure,' 1911. Simmel is more frequently cited for his work on the theory of 'estrangement' wrought by the processes of modernization on the 'sensitive and nervous modern person.' On the architectural consequences of this aspect of Simmel's work, see Vidler (2000, 64–79). For a useful summary of Simmel's work in the context of architectural thinking, see Borden (1997, 313–35).

14. In a different yet complementary contribution to early twentieth-century thinking on mass psychology, Sigmund Freud believed people had developed a 'stimulus shield' that partly anaesthetized them to the speed-up of modern life. Josie Kane discusses how the new rides available in Edwardian pleasure parks were able to pass through this shield and that this was a multisensory experience people increasingly wanted (and were willing to pay for). See Kane (2013), Chap. 5 'Shifting Modernities: Pleasure and Leisure at the Amusement Park' (especially the section 'Speed, Shocks and Kinaesthetic Pleasure' (2013, 204.ff.).

15. For further discussion of the definitions of fun and its difference from pleasure and delight, see Carter (1997, 340–4).

16. Edensor frames his work around certain critiques of affect theory that are based around the latter's lack of historical and socio-contextual awareness. There is an echo in this of the lack of agency granted to crowds by some writers on mass psychology: for a good critique of these writers, see Plotz (2006, 203–23).

 In another of Tim Edensor's articles, co-written with Steve Millington (2013, 145–61), the authors describe the history of the Illuminations, established in 1912, which run for six miles along the seafront of this famous Lancashire town. In their account, in addition to the express interest in atmosphere, cultural value and class, other characteristics of the Illuminations echo my present discussion of the fair-line: the Illuminations also can be considered as a complex physical boundary-limit, and their material, technological and iconographic change over the century of their operation shares close parallels with the impact of changing technologies and fashions on fairground rides and attractions.

17. The fuller quote is: 'One has the impression that "atmosphere" is meant to indicate something indeterminate, difficult to express, even if it is only in order to hide the speaker's own speechlessness... This vague use of the expression atmosphere in aesthetic and political discourse derives from a use in everyday speech which is in many respects much more exact.' Consider also: 'When we stated above that "atmosphere" is used as an expression for something vague, this does not necessarily mean that the meaning of this expression is itself vague' (Böhme 1993, 118). Similarly, Mark Wigley remarks on the slipperiness of the term, for both those who approach it and those who distance themselves from it: 'by definition, it lacks definition' he quips in his conclusion to 'The Architecture of Atmosphere,' 'It is precisely that which escapes analysis' (Wigley 1998, 27). The trajectory of Böhme's discussion is into philosophical aesthetics, which develops an ecological and a bodily aspect, although the general impetus behind his work is relevant for the present discussion.

18. The context of this sentence is Benjamin's discussion of the interior spaces of Adolf Loos' *Haus Müller* (Prague 1930), a high point of 'high' architecture, so some care will be taken to consider the extent to which his analysis survives the transfer to the 'low art' of the fairground.

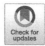

Surface Effect

Abstract This chapter provides a close reading of significant philosophies of surface developed by Andrew Benjamin, Avrum Stroll and Gottfried Semper. Semper's well-known re-writing of architectural history begins with the decorative woven rug or carpet used as an enclosure. Semper's studies occurred at around the same time that the 'good frontages' began to change significantly, with cloth fronts becoming more and more elaborately decorated. Benjamin revisits Semper's theory in light of contemporary interest in surface motivated by new material, fabrication, construction and associated design technologies. He argues that surface effect is neither merely structural nor merely decorative, but a product of the internal logic of the surface. Stroll's interest in perceptual theories of surface moderates and extends Benjamin's work.

Keywords Andrew Benjamin • Avrum Stroll • Gottfried Semper • Space-making

In his essay 'Surface Effects,' Andrew Benjamin is concerned with architecture's interest in surface, and he revisits historical examples (Bernini, Semper and Loos) through a contemporary revival in concern with surface brought about through new material, fabrication, construction and associated design technologies. Benjamin argues that surface effect is neither merely structural nor merely decorative, but a product of the internal

logic of the surface. Like many other contemporary articles on architectural surface, Benjamin's return to the writings of Gottfried Semper is key for his argument. Elsewhere, he has acknowledged that Semper's work has been taken up by a variety of different causes, and he is explicitly critical of Kenneth Frampton's (mis)reading of Semper around the primacy of the joint, which allows Frampton to put Semper's work at the service of a tectonic argument.[1]

Instead, Benjamin returns to 'another Semper' and the primacy of the wall: 'The wall [for Semper] cannot be separated from the effect of space creation. Potentially what counts as a wall need not have anything to do with the literal presence of the wall as a structural element, but will be there in terms of what can be described as the "wall-effect"' (Benjamin 2008, 24). Semper's well-known re-writing of architectural history operates from the starting point of the decorative woven rug or carpet as wall (Semper [1851] 1989, 103). His studies coincidentally occurred at around the same time that the 'good frontages' that occupied the fair-line began to change significantly, with cloth fronts (known as 'show cloths') becoming increasingly elaborately decorated. The historical material and decorative changes that such frontages went through will be outlined in the next chapter. Here, I will continue to focus on the fairground banners and other canvas showfronts from a hundred years ago or more, which can exemplify the operative notion of the fair-line, inasmuch as their material thickness was so slight that they were almost surface without any depth, a pure surface.

For the surface to be granted such a generative effect marked a significant challenge to conventional thinking on architecture's meaning and measures of beauty; moreover, for the exemplar of such generative surfaces to be something as apparently modest as a rug or a carpet troubled many architects and theorists. Even those who pay careful attention to the operative role of the surface still tend to tie this back to material and structural operations that take place behind the scenes. Ulrich Lehmann, for example, makes a nimble theoretical distinction concerning the role of the insubstantial *superficies*, but defines this in oppositional terms to its object: 'when distinguished conceptually from [the object of which they form the perceptual outer layer], they become its antithesis: in insubstantial *superficies* … The surface as thesis, as exterior limit, has as its antithesis the integrity of texture, "finish" and form' (Lehmann 2013, 147). One consequence of Semper's work was that architectural meaning no longer lay in its three-dimensional form (an account that necessarily valorized the building as a

whole), nor in an ornamental supplement or adornment to an edifice (such as that set out in John Ruskin's rival theories, published shortly before Semper's study, and to which I will return in Chap. 5[2]).

Several decades prior to Semper's writing, the groundwork for these shifts in attitude had been brewing, as Anthony Vidler's work on French architectural theory in the late Enlightenment period suggests (Vidler 1987).[3] Most relevant in the present context is the separation or dissolution of architecture's concern with the whole object building that was at the base of classical thinking, which as Vidler notes became split between a plan-based interest in social-spatial organization on the one hand and a communicating surface or façade on the other: 'In this "primitive functionalism," the organization of the plan, the division of built space, was isolated as a tool of social control and reform, while the characteristics of the legible façade were identified in order to make of the building a school of sensations and morals' (Vidler 1986, 3). Lehmann's discussion of very similar shifts and tensions draws attention to the differing dynamics of the fair-line's surface operation. In more general terms, he suggests that 'As a surface moves in its characterization from boundary—and ontological demarcation of empty space—toward an inscribed, coded and commodified projection plane that reflects the values that instrument power relations, its relationship to the object/substance changes.' This closely relates to the two divergent modalities of organization that Vidler observes, and identifies the particular, subtle impact this had on the operation of surface effect of the 'legible façade.' However, Lehmann goes on immediately to argue that 'This shift entails a constant flickering back to the signified of the object, in order to comprehend the meaning that is borne on its instantly accessible surface' (2013, 162). There are two characteristics of the fair-line, and the surfaces it organizes, that fail to conform to Lehmann's flickering, recuperative attempt to return the surface effect to the communication of some notional whole object it fronts; in this, though, some important observations about the fair-line can be made.

Into this situation, Semper's identification of the woven surface at the origin of architecture grants the façade more than just legibility, it took on a space-making role too. For Semper (at least, for the 'other' Semper that Benjamin reads), the rug was a woven element that generated enclosure.[4] It was in this space-generating role that Benjamin locates its contemporary resonance. Beyond the late Enlightenment separation of the plan and the façade just noted, this conception of surface understood it to organize space and enclosure, not simply to offer a supplementary communication

over space via moralizing, instructive facades. The good frontage is not quite caught between these two divergent alternatives (or the flickering rapprochement that Lehmann observes), although it shares certain superficial characteristics of both. Instead, the fair-line as this is conceived and as it is drawn on the layout plan (and physically marked out on site), responds to the internal logics of its system. Benjamin stresses this point forcefully, 'integral to a theoretical engagement with architecture as a practice is the recognition that architecture is necessarily bound up with its means of representation' (2006, 1). While his work on surface effects is focused on 'proper' architectural plans (and the dissimilarity to the fair layouts could not be more pronounced), there are certain aspects that are held in common concerning the primacy of space effecting. More forcefully, the fair is not a whole object, an issue to which I will return in Chap. 7; any objects that are identified with it are subordinate to the broader logic of space creation.

As Bostock's mantra reminds us, the good frontages were conceptually, as well as formally, slightly separate from the actual content or form of the attraction behind. To assert this in slightly different terms, fairground attractions—at least in their composite surface arrangement along the fair-line—were not three-dimensional, they were never really reliant on an 'object' behind them that they referred back to for meaning. Indeed, quite the opposite: any connection to a 'behind' or 'back' is a loaded suggestion here, as the good frontage operated (and continues to operate, albeit with some different material arrangements) primarily without any reliance on or reference to a whole object. The fair layout follows a plan unconnected to any governance by a kind of ideality; it is underwritten neither by an intention to arrange individual fairground objects in neutral, metric space, nor by instigating a sweeping spatial order. For the fair to work as a larger space, particularly by generating and sustaining the atmosphere introduced earlier, it needed a boundary that was not merely nominal, but effective (in the full, loaded sense of the term in the present context). Diverting Theo van Doesburg's assertion to this context: 'Ultimately only the surface is crucial for architecture, man does not live in the construction, but in the atmosphere that is evoked by the surface' (Van Doesburg 1929).[5] Within this logic, the good frontages actively sought, individually, to obfuscate the reality of the attraction on offer; they also sought, individually and collectively, to separate the space of the fair from the other, static architectural objects of the town that were situated behind the fair-line.

This split of responsibility and role between plan and façade, metric spatial organization and communication, fails to play out in the various ways that Vidler or Lehmann suggests in other contexts: nevertheless, it anticipates other aspects of the very loose relationship that I have described between the fair-line as this was drawn very simply on plan and the significant, generative surface produced by the early canvas frontages of the fair. As canvas gave way to increasingly elaborate wooden carving, this difference is increasingly stark on the various drawings produced by the manufacturers of rides and attractions.[6] Figures 3.1 and 3.2 shows some examples of drawings from Orton and Spooner archives, demonstrating the rococo exuberance of these façade designs, in contrast to the mute, functional and organizational concern of the fair layout drawings such as those in Figs. 2.1 and 2.2.

In contradistinction to other more conventional architectural understandings that separated the secondary role of surface and ornament from a primary architectural structure (where space was neutral, ready to be divided and then decorated), and from a more recent architecture of styles

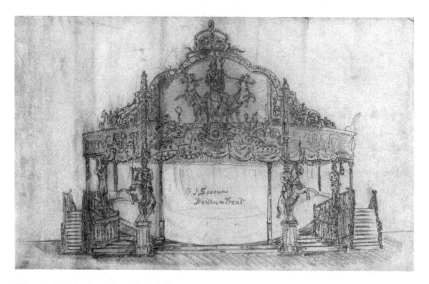

Fig. 3.1 Design drawings, George Orton, Sons and Spooner Limited, circa 1910. (Orton and Spooner Collection from the David Braithwaite Collection. Reproduced with permission from the University of Sheffield Library, National Fairground and Circus Archive)

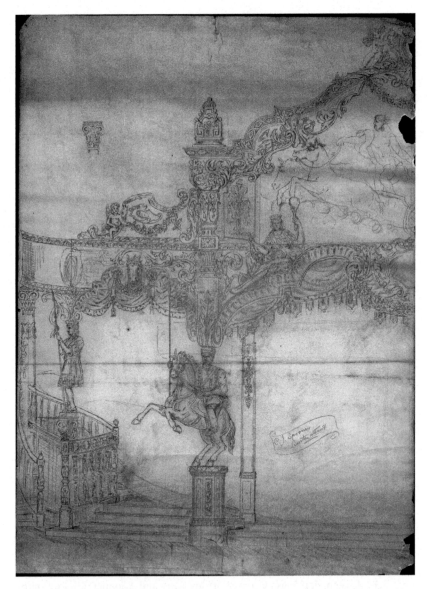

Fig. 3.2 Design drawings, George Orton, Sons and Spooner Limited, circa 1910. (Orton and Spooner Collection from the David Braithwaite Collection. Reproduced with permission from the University of Sheffield Library, National Fairground and Circus Archive)

and signs (an antispatial architecture of communication over space), the Benjamin-Semper conception of surface effect understands surface to generate space (and influence atmosphere). More precisely, this role is 'internal to the surface as an operative field' (Benjamin 2006, 3).[7] Surface makes space, even when surface is established only by carpets or canvas banners. For Semper, this was not conceived of as a development of architectural tectonics, form or prior structure, but a thorough revisionist history of architecture that stretched back to a new origin myth and retold the story around the primacy of surface effect. Lehmann states that his particular interest is beyond (although includes) the extension and interplay that he identifies between surface and superficiality—the insubstantial *superficies* mentioned above—and more concerned with how 'the surface is ... posited as a construction that determines what is interior to it' (Lehmann 2013, 148). Following Semper, we might add what is anterior to it. Within the terms of Benjamin's analysis, and of Semper's thesis, this raises a number of particular challenges that are discussed in more detail later in the book. In particular, certain 'exceptional' examples conceded by Semper will be discussed in Chap. 5, within a consideration of illusory instances of surface effect along the fair-line. These further the fair's move to cut itself off from the world outside, a surface effect that avoids any reference to a 'whole object' behind the fair-line. The space-effecting consequences will be discussed further in Chap. 6 around issues that posit the enclosed fairground as an interior space, again with a complex relation to that which forms its bounding surface or horizon and that which lies outwith the fair. In order to establish the material, technological, cultural and historical context for these discussions, the following chapter will introduce the longer development of the good frontage.

NOTES

1. To Frampton, others could be added, including those already mentioned in Chap. 1, Alejandro Zaera-Polo and Lars Spuybroek.
2. Harry Francis Mallgrave alludes to Semper and Ruskin as 'kindred spirits' because they undertook 'extended foray[s] into the origin and unfolding of art-forms' (Mallgrave 2004, 1). Ruskin's *Modern Painters* was first published in 1843, *The Seven Lamps of Architecture* in 1849, and the first volume of his *Stones of Venice* in 1851.
3. Vidler links this tendency to the production of various institutional origin myths, including those for architecture typified by Laugier's 'primitive hut.'

Semper's work, of course, provided a different myth for the origin of architecture. It should be noted that Semper studied architecture during two long stays in Paris between 1826 and 1830 and was again based there at mid-century when trying to publish his work on *The Four Elements of Architecture*. For a detailed account, see Harry Francis Mallgrave's intellectual biography of Semper (Malgrave 1996, esp. 'Paris, Bremerhaven, Paris,' 18–25, and 'Refugee in Paris and London: 1849–1855,' 165–228).

4. It was one of four elements Semper identified from early post-nomadic settlements, along with the hearth, the mound and the roof, and the one which he discusses at greatest length. He describes the hearth as 'the first and most important, the *moral* element of architecture. Around it were grouped the three other elements: the *roof*, the *enclosure* and the *mound*, the protecting negations or defenders of the hearth's flame against the three hostile elements of nature' (Semper [1851] 1989a, b, 102), all original emphasis. Semper acknowledges that the form and arrangement of these elements reflect differing influences of climate, culture, technical skill and so on.

5. Translated and cited by Fritz Neumeyer (1999, 252). Neumeyer's article is situated within a very different (tectonic, phenomenological) tradition of surface thinking to that pursued here.

6. The endurance of pseudo-baroque and rococo characteristics on showfronts is notable, although the reasons for this popularity are beyond the scope of this work to pursue. It is interesting to note the connection that is made by Peter Buchanan between baroque architecture and atmosphere: 'The self-conscious and theorized pursuit of atmosphere started with the Baroque period' (1998, 80).

7. It should be noted that the examples Benjamin brings into play around Semper—Bernini and Loos—belong to two of the most significant space-making architectural moments, the Baroque and early high modernist periods, which arguably do recombine both the drawing up of plans and the spatial effects of surface in a complementary combination.

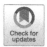

From Canvas to Carving, Ornament and Supplement

Abstract This chapter rehearses the material development of fairground frontages as these grew in scale, solidity and complexity through the 1890s and into the twentieth century. Making reference to the work of ride manufacturers Orton and Spooner, it contextualizes these changes within the shifts that have taken place in the overall fair layout during the same period using Semper's concept of 'Stoffwechsel,' the translation or metamorphosis of decorative effects from one material into another. Comparisons are drawn between these material changes and other work with cloth, particularly Abel Blouet and Michael Faraday's collaborative experiments during the 1830s. Their interest was to reduce communication between prisoners in adjacent prison cells: the relevance for the operation of the good frontage is explored.

Keywords Ornament • Decoration • Fairground attractions • *Stoffwechsel* • Misinformation • Orton and Spooner

In his short book on *Travelling Fairs,* David Braithwaite sketches out the early material and decorative history of fairground frontages. He suggests that 'from observation and first-hand experience of point-of-sale it was found that display with a flourish invariably drew a crowd,' and continues: 'Drab box-like booths were thus decorated with flags, gaily painted placards and roll-up canvases suspended on poles. Open-fronted stalls for games and trading were enriched by painted uprights and shutters and by

© The Author(s) 2018
S. Walker, *The Fair-Line and the Good Frontage,*
https://doi.org/10.1007/978-981-10-7974-0_4

embroidered cloths hung internally. The showfront soon emerged as a distinctive feature. Its paintings advertised the spectacle within as well as forming a backdrop for barkers and paraders who performed on a platform to spectator eye-level' (Braithwaite 1976, 5). Returning to Andrew Benjamin's consideration of Semper, he draws attention to how surfaces work to create spatial effect: of particular relevance for this chapter is his analysis of the relationship between the ingredients—the materials, ornaments and their relationship to a longer history of making as well as to any supporting structure—that together generate the 'operative field' of the surface. From a passage written in response to the work of Adolf Loos, and already cited above, Benjamin emphasizes how surfaces do not simply function as divisions in some sort of neutral space, as decorative coverings to the establishing work of architectural form or enclosure, but as the primary space-effecting elements. It is worth repeating here: 'The effects—the creation of affect—however come from the operation of material and forms. Effects are the work of surfaces that create spaces' (Benjamin 2006, 24–5).

Although Benjamin's broad interest in the ways that surfaces effect atmosphere does not seem out of place in a consideration of fairgrounds, his architectural protagonists—and here particularly, his consideration of Loos, an architect who is widely caricatured by his (in)famous lecture *Ornament and Crime* (Loos [1908] 1985, 100–103)—seem a long way from the *flags, gaily painted placards and roll-up canvases* that Braithwaite describes on the fairground. Nevertheless, the connection is worth pursuing, because for Loos (and Semper), the changing role and material manifestation of ornament on a surface was key to their understanding of architecture. Indeed, for Semper (and Loos), the evolution of ornament across successive changes in material and construction provided one of the main indicators through which the threads of architecture's developing history could be traced and told. Semper introduced the concept of *Stoffwechsel* to help account for this metamorphosis of materials, decoration and ornamentation in architecture, from its earliest manifestation through to contemporary approaches. Coincidentally, the story of the showfront shares a material origin with Semper's story of architecture, as both spring forth from a hung textile, and the showfront's evolution echoes many of the material changes that architecture has enjoyed, albeit within a significantly compressed time period. These changes provide the main focus of this chapter, but this is not a simple material history: as Semper's *Stoffwechsel* demands, across these various metamorphoses a more enduring set of concerns and characteristics can be identified in the

surface, passed between different material and technological supports. The legacy of mythico-original materially determined decoration and ornament is retained through these sequences of material passage. More significant, the performance of the surface as an operative field persists. The factors that influence the 'creation of surface effects' can be identified, and their particular *Stoffwechsel* trajectory discussed, operating at a variety of scales along the fair-line, and in complex concert with the surrounding surface architectures of the host town (Figs. 4.1 and 4.2).

Vanessa Toulmin has described how the show cloths or 'decorated banners, illustrating an exaggerated account of the spectacle inside the show, could be found on fairgrounds throughout the country. The visual feast pictured was not always the exact reality that confronted the spectator, but served to entice the crowd' (Toulmin 2003, 7). Although the disparity between the promise on the front and the experience of the show within was often marked, I am more interested in other instances of misinformation that the story of the show cloths enjoys. In terms of their own origin and

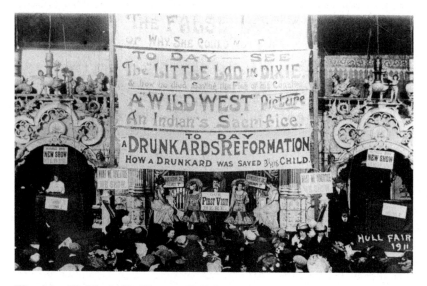

Fig. 4.1 H. Marshall's *Bioscope*, Hull Fair, 1911. Carved frontage with canvas banners advertising various shows, including *Drunkard's Reformation*, *Indian's Sacrifice*, *The Little Lad in Dixie* and *The False Lover* (Postcard reproduction copyright Leeds Traction Engine Society. Reproduced with permission from the Leeds and District Traction Engine Club)

Fig. 4.2 Tom Wortley's *Christiana Tattooed Princess Show*, Hull, 1912 (National Fairground and Circus Archive Collection. Reproduced with permission from the University of Sheffield Library, National Fairground and Circus Archive)

development, something of a myth circulates concerning the links between show cloths and Trade Union banners, due to similarities in their lavish decoration and style. Toulmin again: 'Although the actual makers of many of these banners are unknown, the decorative tradition found on the show fronts is similar to the style used by Trade Unions in the 1850s. This is due in part to the banners produced by George Tutill, a one-time travelling showman who left the fair in the 1830s to concentrate purely on banner making for the fledgling trade union movement' (Toulmin 2003, 7). Roger Logan traces and challenges the origin myth that has been put about concerning this link to Tutill: 'In the previously most comprehensive published account of George Tutill's life, John Gorman in *Banner Bright* suggested that he grew up as "a travelling fairground showman" [but] there is no available evidence to confirm or refute the contention that during his youthful years he was involved with travelling fairs or shows' (Logan 2012, 48 & 8, referring to Gorman 1976). Semper was much more reflective about his position as a lone voice for the woven carpet enclosure as architecture's origin: 'I seem to stand without the support of a single authority when I assert that the carpet wall plays a most important role in the general history of art' (Semper [1851] 1989, 103).[1]

The use of cloth in supporting misinformation finds a surprising parallel in Abel Blouet and Michael Faraday's collaborative experiments during the 1830s to reduce communication between prisoners in adjacent cells. Discussing these experiments, Robin Evans notes that 'the best performance of all [their experiments] was obtained by introducing two limp sheets of sail cloth into one of these serrated [wall] cavities … through which any word was transposed into a muddled blur by the time it reached the other side' (Evans [1971] 1997, 47)[2] (Fig. 4.3). In contrast to this approach, other regimes sought a total separation between inside and outside. Slightly earlier than Blouet and Faraday's work (and also of interest to the French state), the New York State's Auburn Prison 'Silent System,' as its name suggests, strictly imposed silence at all times. Brandon LaBelle notes how 'Silence in this regard functioned as an absolute form of surveillance, control, and isolation… At night, sock-wearing guards would walk through the prison, listening for any clandestine whisper, hushed murmur, or subtle noise among the prisoners' (LaBelle 2010, 69).[3] The differences between these two approaches to control illustrate broader architectural

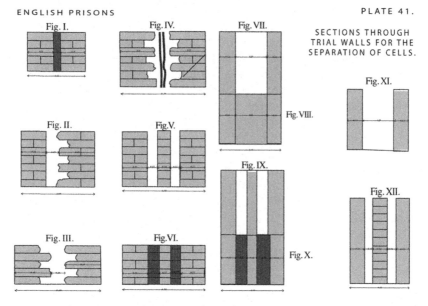

Fig. 4.3 Abel Blouet and Michael Faraday's collaborative experiments during the 1830s (Redrawn by Benjamin and Stephen Walker)

positions concerning surface control that are relevant to the present considerations of the individual showfront and collective performance of these along the fair-line.

In contrast to the Auburn 'Silent System,' the intention of Blouet and Faraday's sail cloth composite was not to reduce (or eliminate) noise transmission but the transmission of intelligible information or messages. From tragedy to farce, this is repeated in the organizational logic of the surface-boundary established along the fair-line, as noted earlier. Indeed, this particular characteristic of the fair's surface-boundary was strengthened as a by-product of other historical changes taking place in the fairground; firstly, the waxing of the rides and the waning of the shows as the main fairground attractions, such that shows were 'pushed ... to the perimeter of the fairground' (Toulmin 2003, 12) where they formed a more continuous boundary, and secondly, the increasing size and effect of the 'good frontages' themselves. At these two scales of consideration, two distinct modes of surface logic can be identified—an overall communication scramble produced by the composite fair-line surface-boundary-limit, and a material/ornamental logic at play on the surface of the individual rides.

The fuller story of the development of showfrontages is caught up in the more complex history of the fair as this developed during the nineteenth and twentieth centuries, with the attendant social, cultural, political and technological dynamics this involved, and its detail is beyond the scope of this book. Several excellent accounts are available of the evolution of fairground rides and the fairground art that was an integral part of their surface logic.[4] These accounts are fairly consistent, tracing the change from canvas to carved wooden frontages that reached a high point of size and ornate complexity in the great Bioscope shows of the Edwardian era, associated above all others with the manufacturers Orton and Spooner, based in Burton on Trent, England.

Geoff Weedon and Richard Ward describe how frontages grew in size and complexity during the nineteenth century. Platforms and steps-up were added to the *drab box-like booths* that Braithwaite noted, as well as various bits and pieces of ornamentation, although the main flats were still painted canvas. This composite material surface was replaced—its effects replicated—with carved wooden fronts, the use of which peaked during the Edwardian era, on the Bioscope shows in particular, such as that shown in Fig. 4.4. Alan S. Howell describes how

> [t]he great success of the Bioscope shows encouraged their owners to purchase larger, more prestigious showfronts ... The profusion of scrollwork,

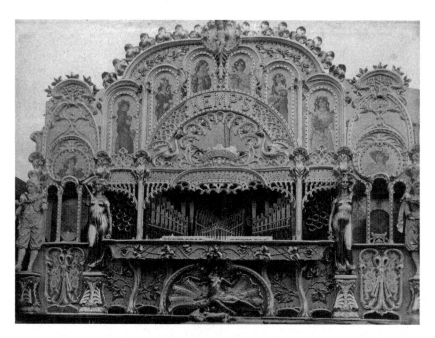

Fig. 4.4 President Kemp's *Marenghi Organ* from the Bioscope show, George Orton, Sons and Spooner Works Photograph, 1906 (Orton and Spooner Collection from the David Braithwaite Collection. Reproduced with permission from the University of Sheffield Library, National Fairground and Circus Archive)

pilasters, figurines and ornate borders perfectly suited the ostentatious spirit of the fairground. The showfronts were a mass of visual superlatives whose excess must have impressed and delighted the public. (Weedon and Ward 1981, 127)[5]

In addition to the overall popular and financial success of these Bioscope shows, competition between owners fuelled the increasingly elaborate decoration. Howell echoes a broad consensus 'Those [showfronts] produced by Orton [and Spooner]'s were generally considered the most elaborate, particularly when combined with gigantic fairground organs' (Howell 2003, 5).

Although the dominant material and surface became carved wood, canvas banners remained part of the surface ensemble. The wider range of decorative skills possessed by the craftsmen working at Orton and Spooner's and other manufacturers, as well as the range of other work they undertook, is indicated by an advert placed in the *World's Fair*, the weekly

publication read by all those in the fairground business, in February 1909: 'A S Howell, Artist and Decorator, high class painting and decoration for all kinds of exhibitions' (cited in Howell 2003, 12). As well as his trademark decorated shields, 'He [Albert Sidney Howell, the author's grandfather] also became skilled in decorating fairground showfronts, panels and banners for the many travelling Menageries and Bioscopes that were so popular at that time' (Howell 2003, 16).

The Bioscope as an attraction disappeared, moving from the travelling fairground into the more static architectural fabric of towns and cities across Europe, although the size of the showfronts and the extent of the elaborate decoration remained fairly constant, as can be seen in the image of Proctor's Scenic shown in Fig. 4.5.[6] 'It is hard these days to imagine the massive dimensions of these rides … Some of the rounding boards were 170 feet in circumference and anything in excess of twelve feet in height. This meant over two thousand square feet of design artistry was required

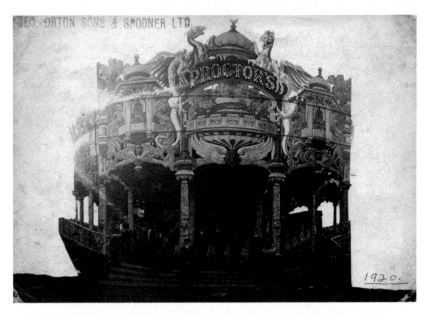

Fig. 4.5 Proctor's Scenic, manufactured by George Orton, Sons and Spooner Limited, 1920. (Works Photo) (Orton and Spooner Collection from the David Braithwaite Collection. Reproduced with permission from the University of Sheffield Library, National Fairground and Circus Archive)

on each machine, some challenge for any artist!' (Howell 2003, 27). Weedon and Ward note how a significant shift away from this 'heavy ornament' began during the 1930s, when it was replaced by increasingly lightweight decoration (and later still, by the emergence of a ride's raw machinery from behind the decorative surface). The reasons for this change are complex, but primarily practical and economic: the heavily ornamented attractions and rides were expensive to make, slow to transport and difficult to erect and dismantle. Broader changes to manufacturing processes during the late 1920s and 1930s saw new types of rides produced. As Howell observes, these were 'easier to build, decorate, transport and were very cost effective; in some cases they were less than half the price of previous machines' (Howell 2003, 9). The mass production that brought down the cost of the ride itself also found its way into new techniques of decoration: the complex timber carving that had marked out the rides of the previous generation gave way to painted flats, and increasingly deploying stencil work decoration, leaving hand-painted set-pieces concentrated around significant thresholds or features (Fig. 4.6). Howell describes how the role of 'Artists and Decorators' changed as a result, noting the way his grandfather began to design standard decorative patterns and stencils. As head of a workshop, Howell's creative input would be increasingly directed at the design rather than the application of these applied surface decorations, and to the smaller-scale scenic decorative artwork around a ride entrance: the remainder of the decoration would be left to the 'painting team.'[7]

From World War I onwards (or even earlier, in parallel with carved work), painted flats included the semblance of three-dimensional carved work, as well as scenic decoration. This illusion of three-dimensionality was epitomized perhaps by the post-World War II hand-painted artwork of Fred Fowle (Fig. 4.7) In turn, hand-painting has increasingly given way to airbrushed work, and more recently to digitally produced decoration and imagery (digitally designed or collaged, then applied using vinyl transfer methods, and more recently directly printed onto aluminum dibond panels).

This is relevant not simply as a brief history of showfronts, but in its echoes of the metamorphosis that Semper mythologizes over a much longer time period, with the characteristics of certain material and production techniques being passed on to subsequent, different surface materials (woven textiles into surface patterns or ceramic shapes, for example.) Although the material parallels are notable—from hung fabrics to more

Fig. 4.6 Southampton Common Fair, 1955 (Arthur Jones Collection. Reproduced with permission from the University of Sheffield Library, National Fairground and Circus Archive)

Fig. 4.7 Hall and Fowle décor on Thurston's Ark *Ben Hur* (detail of shutters) photographed by Jack Leeson at Bedford Fair, 20 April 1962 (Jack Leeson Collection. Reproduced with permission from the University of Sheffield Library, National Fairground and Circus Archive)

solid surfaces through to today's digitally designed and fabricated façades—it is important to stress that across this metamorphosis of showfronts, they are getting on with the production of surface effect, or the production of the 'good frontage' that Bostock advocated.

Metamorphosing at different rates, these two stories of the surface intersect in particularly illuminating ways during the first third of the twentieth century. The period when the large, ornate showfronts just noted dominated the fairground coincides with the emergence of a dominant brand of architectural modernism, with its smooth white-wall signature.[8] Mark Wigley does much to qualify and challenge this white-walled caricature, and his careful readings provide a succession of issues and warnings that can support an analysis of the surface effects of these evolving showfronts. Despite the awkwardness of this association, the surfaces of showfrontages and modern architecture are interesting to hold together. It is easy to suggest that there is a certain repression in the latter, visibly and conceptually casting off the decorative excesses of other architectures that are collaged together in the former. But as Wigley's analysis demonstrates, the self-appointed key figures in the modern movement—Loos and Le Corbusier in particular—followed the logic of Semper's theory of surface far more closely than their declarations would suggest. In particular, it is the complex relationship to time, and to change over time, that can be drawn out here, especially concerning the relationships between surface, decoration, ornament, fashion, style and Semper's notion of *Stoffwechsel*.

Returning to the experiments in separation and control undertaken by prison systems introduced earlier and forcing the analogy yet further, there is a certain equivalence between the 'silent system' and the white walls that exercise Wigley. Like the silent regime that imposed a total separation between individual prisoners, and between them and their guards, the white walls of modernism set themselves up not only as emblematic of a new architecture, they also acted as a surveillance device that required constant upkeep or maintenance in various directions and dimensions. Indeed, in his 'Introduction,' Wigley probes the blind spot of the white wall's self-proclaimed neutrality, arguing that its surveillance operations occur materially and conceptually: as soon as the white surface starts to age, dirty, stain or decay, the quasi-transcendental claims of modernism are revealed simply as a fashion, a passing fad: 'superficial flaws become deep threats.' (Wigley 1995, xix). This self-policing role given to the white surface—literally to the outermost whitewashed or white-painted finish epitomized by Le Corbusier's *Law of Ripolin*—was to guard architecture against the

temptation to give in to the churn of fashion.[9] As Wigley goes on to argue: 'The white surface marks the disavowal of the structural role of surface. The existence of one surface that denies surface—whether it be in one part of a building, or one part of a theory, or one historical moment—sustains an economy in which surface is everywhere subordinated' (Wigley 1995, 122–3). This subordination is effectively the repression of surface effect, the denial of the space-generating role performed by surfaces. The white surface was set up as a degree-zero of decoration and change, the overcoming of (fleeting) fashion by (enduring, transcendent) style.

Significant amongst the many complex, contributory factors involved in the emergence of the white-walled brand of modernism was a particular sense of modernity that was prepared to celebrate certain aspects of material and technological change while repressing the consequences (particularly as these became manifest in a general speeding-up of life, more rapid change to urban and working environments and so on). Although in more general terms both architectural production and the fairground environment were caught up in and affected by changes in technology and social practices, the extent to which, and the modality within which, this was expressed on their respective surfaces was significantly different. In contrast to the 'silence' that the white wall offered when faced with the noise of this speed-up, the good frontage of the fair-line can be understood to enjoy a different, albeit inversely related, status and dynamic. Unlike the eternal present sought by the white wall, the evolution of the showfront since the early twentieth century demonstrates both a continuing belief in the space-generating capacity of surface and a tendency to continually overpaint outmoded fashions with the new.

Arguably modern architecture was trying to present or impose a certain understanding of time on the production of architecture and the designed environment, but the fair and many other areas of everyday life were experiencing rapid, varied and frequently threatening challenges to previously held conceptions of time. The fair, then as now, rolled with the changes: there is arguably no medium or environment better attuned to changes in the zeitgeist, or as forgiving in its appropriation of them.[10] If the white surface of modern architecture operated as a surveillance device, so did the good frontage of the fair, although with very different sensitivities and results. If there is any self-policing going on within the showfront, it is directed against stasis: as individual attractions, rides had to ensure they were seen to move with the times, or punters would spend their money elsewhere along the fair-line. The frequency with which rides and attractions change to reflect changing fashions in popular taste continues to increase.

The fairground's pursuit of novelty, in its general array and the particular surfaces of the showfronts, is antithetical to modernism's declaimed rejection of fashion. Wigley notes how 'The white surface is the antifashion look' (1995, xxii), and one thread that runs through much of his book pursues the structural conditions of the struggle between fashion and resistance to fashion. Indeed, he accounts for how modernism sought to put itself above the flux of fashion and attain a transcendent purity or style: 'To produce [this], fashion has to be "disciplined" by reducing decoration' (Wigley 1995, 152). At face value then, the dense accumulation of decoration that characterized the showfronts smacks of indiscipline, and thus confirms broader condemnation of the fair as a site bereft of moral rectitude. Moreover, it confirms the showfront's involvement in a more complex temporality than contemporaneous modern architecture.

Exploring this in more detail, it is useful to pursue the distinction Wigley makes between decoration and ornamentation: 'Ornament is aligned with time rather than against structure. To produce a modern architecture is not to strip the ornament off a building, but to preserve the building from the fast-moving time of the fashion world that would render it ornamental, whether the particular look is highly decorative or not' (Wigley 1995, 174). With this warning, Wigley effectively returns us to Semper, to the emphasis Semper placed on architectural surface rather than structure and to the temporal development of materiality and ornament. It also returns us to the challenge presented by the showfronts, where decoration, ornament and structure have been compressed into such a two-dimensional composite, within which the phases and rhythms of development are less legible. In a recent book that responds to a certain resurgence in architectural ornament (or decoration, as the terms are used here fairly interchangeably), Antoine Picon goes some way to return attention to ornament. However, he still positions ornament as an architectural supplement—an addition—to the structure of the building. In temporal terms, architecture-as-building comes first in this account, and then an ornamental supplement follows along. 'From a philosophical standpoint, ornament was an illustration of the disconcerting capacity of the supplement to become a defining feature of that to which it was added, a situation admirably analysed by Jacques Derrida in texts such as *Of Grammatology*' (Picon 2013, 38). Although Picon advocates on behalf of the supplement, rather than dismissing or disciplining it the way modernism's white walls did, more attention could have been given to the 'admirable analysis' set out in the works of Derrida. (Indeed, positioning ornament as the supplement or adornment to any building,

Picon's argument is very Ruskinian, something to which we will return indirectly in the next chapter.) A Derridean reading would challenge assumptions concerning what is taken to be ornamental or supplementary, demonstrating that these always-already play a role within a major structure. On Semper's terms, the ornamental surface was not the supplement but the primary spatial enclosure: it might have become secondary in the minds of many, but this was a by-product of changes that took place through a long evolution from its original or core role, as ornamental motifs inherent or integral to one material and its associated manufacturing or production techniques were translated onto the finishes of other materials that had different properties.

As mentioned earlier in this chapter, Semper termed this process of transformation *Stoffwechsel*. In *The House that Semper Built*, Elena Chestnova sets out an extended discussion of Semper's *Stoffwechsel*, drawing out aspects of this process that help account for the evolution and operation of the good frontage and the differences in its history and logic compared to the architectures that are usually discussed with reference to Semper. Chestnova notes how, for Semper, 'forms, with the help of *Stoffwechsel*, transgress material boundaries' (Chestnova 2016, 55).[11] While many architectural accounts seek out, or seek to situate, instances of formal evolution within a progressive telling of architectural history, the transgressive aspect of this process, the slippage between form (or ornament) and material, can progress in other ways. One of the targets of white-wall modernism that Wigley analyses was the perceived excessive decoration of nineteenth-century ornament. In the present context, it is the interaction between observer and building that is particularly relevant. Wigley rehearses a certain fear or repulsion perceived by modern architects in the early years of the twentieth century when faced with the ornamental architecture of their recent past. He notes how '[t]he body of the building and the body of the observer disappear into the sensuous excesses of decoration. To look at decoration is to be absorbed by it. Vision itself is swallowed by the sensuous surface' (Wigley 1995, 7). White-walled modernism advocated a controlled separation between body and building, or more forcefully between the stuff of the world and a mental, transcendent realm in which modern architecture should be sought. Decoration—particularly the excessive decorative surfaces of the nineteenth century—threatened this control, as the clear self-identification of a body behind or outside the architectural surface disappears when faced with so much decorative froth. But clearly, the good frontage of the fair offered an abundance of decoration, excessive even by nineteenth-century measures.

To put this in a different register, evolution is not only evident in the form of surface as this metamorphoses, prompted by changes in materiality, but also, simultaneously, the construction of an eye, an observer, an economy of vision. In contrast to the institutionalization of vision that modernism promoted in tandem with the clean white surface, there is another economy of vision, another eye, evolving with the good surface of the showfront. In Wigley's terms, the showfront can very clearly be understood to operate an economy whose decoration absorbs the spectator and swallows them up: the role of the good frontage, as stated explicitly by Bostock, is to distract attention from what goes on in the show itself. It operates to deny any overall form for the show, ride or attraction, providing an absorbing disguise behind which anything that is (over)claimed on the outside could conceivably go on. If the showfront evolved to produce effect, atmosphere, it also produces a different eye/body, a different visual/somatic economy to that set out by modernism.

Moreover, Chestnova's analysis of *Stoffwechsel* suggests Semper's theory is far more accommodating than the versions of it read through or internalized (overtly or covertly) by architectural modernists, for whom Semperian evolution culminates in whiteness as ornamentation degree-zero, devoid of superficial decoration. In contrast, the showfronts along the fair-line promote an alternate evolutionary story, one that arguably is closer to the logic of Semper's architectural theory. Chestnova emphasizes how Semper's approach has to be underwritten by a certain generosity of accumulation, in order to accommodate the wide-ranging architectural history that he writes:

> It is the combination of the physical properties of the artefact with the inter-
> pretation of the observer that gives *Stoffwechsel* its narrative stickiness. This is
> why it allows Semper to overcome the differences of origin, meaning, and
> culture in his object references, as well as those of material. *Stoffwechsel* is an
> effective integrative device that permits Semper to unite a disparate multitude
> of artefacts into a coherent collection. Without it, Semper's catalogue would
> make no sense as a history of art and architecture. (Chestnova 2016, 54)

Taking up Chestnova's assertive analysis, it fits even more comfortably onto the short history of the showfront than it does onto Semper's expanded origin-myth-history of architecture. The showfronts and their interpretive economy operate as a generous integrative device, uniting elements with various *origins, meanings, and cultures in their object references,* and evolving or metamorphosing at greater speed than Semper's own account of architecture. Indeed, the archival material available from manufacturers Orton

and Spooner reveals something of their integrative approach to designing showfronts. Amongst the design and manufacturing drawings of rides from around the turn of the century, there are several significant architectural pattern books, including Paul Rouaix's *Les Styles*, E. Braun's *Kunstmythologie*, a *Paris Exposition 1900* catalogue containing views of the exhibition and Paris and Emil Braun's *Formenschatz der Renaissance*, examples of which are shown in Fig. 4.8. Additionally, there are several loose sheets pulled out of the journals *The Builder* and *The Building News* from the 1860s and 1890s (including a reproduction of the 'Tuscan Order for columns and arches' from Sir William Chamber's 1759 *Treatise on the Decorative Part of Civil Architecture* (Fig. 4.9)) as well as the catalogue for Tynecastle Cornices (Fig. 4.10), which illustrated a wide range of decorative architectural mouldings.[12] Together, these provided Orton and Spooner with a wide range of architectural elements of various historical, cultural and material origins, which they happily collaged and augmented in their designs.

Indeed, given the various techniques for *uniting a disparate multitude of artefacts into a coherent collection* adopted by Semper and by Orton and Spooner, it is somewhat ironic to read in another significant encyclopedic work—*The Grammar of Ornament* by Owen Jones [1859]—of the author's intention to stop the tendency of his contemporaries to *overcome the differences of origin, meaning and culture* in their collaged, integrative designs. In the Preface to the folio edition, Jones notes

> I have ventured to hope that, in thus bringing into immediate juxtaposition the many forms of beauty which every style of ornament presents, I might aid in arresting that unfortunate tendency of our time to be content with copying, whilst the fashion lasts, the forms peculiar to any bygone age, without attempting to ascertain, generally completely ignoring, the peculiar circumstances which rendered an ornament beautiful, because it was appropriate, and which as expressive of other wants, when thus transplanted, entirely fails. (Jones 1859, 1)

Indeed, Jones anticipates that the effects of his labour might be to accelerate rather than arrest the tendency to design by collaging, writing that '[i]t is more than probable that the first result of sending forth to the world this collection will be seriously to increase this dangerous tendency' (Jones 1859, 1–2). Certainly, the role played by these kinds of nineteenth-century 'collections' is evident in the work of Orton and Spooner, emblematic of the broader production of good frontages, which actively and willingly accepted and transplanted the forms of bygone ages (Fig. 4.11).

Fig. 4.8 Paul Rouaix's *Les Styles*, E. Braun's *Kunstmythologie*, a *Paris Exposition 1900* catalogue containing views of the exhibition and Paris (Orton and Spooner Collection from the David Braithwaite Collection. Reproduced with permission from the University of Sheffield Library, National Fairground and Circus Archive)

Fig. 4.9 Sir William Chamber's Treatise (on *Civil Architecture*), [1759] showing the Tuscan Order for columns and arches, 'Published by the Proprietors of the Building News, 1860' Orton and Spooner Collection from the David Braithwaite Collection. Reproduced with permission from the University of Sheffield Library, National Fairground and Circus Archive

Fig. 4.10 Catalogue for Tynecastle Cornices, which illustrated a wide range of decorative architectural mouldings, and George Orton, Sons and Spooner Limited works photo, sample of early carved work c.1880 (Orton and Spooner Collection from the David Braithwaite Collection. Reproduced with permission from the University of Sheffield Library, National Fairground and Circus Archive)

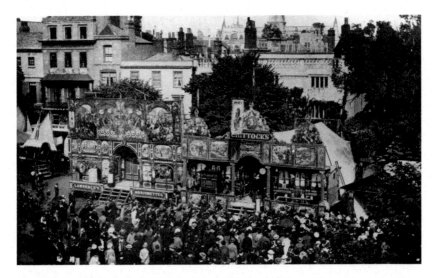

Fig. 4.11 Lawrence's *Marionettes* and Chittock's *Menagerie*, Oxford St. Giles' Fair 1885 (Philip Bradley Collection. Reproduced with permission from the University of Sheffield Library, National Fairground and Circus Archive)

Moreover, when showfronts were updated to remain competitive and appealing in the crowded fairground market, a similar integrative, collaged approach was frequently taken. One exemplary story of ongoing change from the early years of the twentieth century is told by Father Greville, writing in his memoirs of Oxford St. Giles' Fair and the frequent alterations he witnessed to some of the frontages:

> Jacob Studt's show was the largest and best double wagon show front to appear [at Oxford St Giles' Fair], and even when in 1907 it was equipped with a large 110 Key Gavioli organ the front was not discarded like most were, but lengthened, the wagons remaining each side of the organ, but with entrances to the show in between … In 1909, four very massive columns had taken the place of the ordinary pillars on the showfront, each surmounted by elaborately carved Corinthian capitals. It looked massive, to say the least. (Greville 1949, 7)[13]

In addition to these two variations of the effective integrative device accounted for as *Stoffwechsel*—the initial workshop design of showfronts and the re- or over-working of the façades of existing rides recounted by Father Greville (a practice that goes on to this day)—there is a further

Stoffwechsel that has emerged and evolved internally along the fair-line, the temporal dynamics of which have become more complex and potentially contradictory as the fairground as an environment enjoys a more complex and reflective engagement in its own tradition. Granted the composite arrangement of showfronts along the fair-line has always been something of a hotchpotch, the overall internal logic of this arrangement was coherent. Early canvas frontages projected distorted or exaggerated claims of what was on offer inside, using supergraphics and few images that later became mixed with other decorative elements borrowed from the wide range of sources noted above, all collaged together into singular compositions that were in turn overworked and updated to promise novelty, alongside genuinely new rides and attractions that were, and continue to be, introduced to the fair. As the fair has developed enough of a history to claim a distinction between the simply 'outdated' and the 'classic' rides and attractions of a previous age, the latter have found their way back into overall collaged surface of the fair-line. In this more recent manifestation, not only are individual decorative elements of single rides drawn from wide-ranging historical origins, but the historical periods to which individual rides belong (or claim to belong) are now also collaged together into the composite whole, introducing another scale of historical integration and *Stoffwechsel*.[14]

Reflecting on the dynamics of the architectural recycling of forms across architecture's longer historical developments, Andrew Benjamin makes reference to the work of Emile Kaufmann, arguing that the importance of Kaufmann's contribution to architectural theory is his analysis of the distinction between different architectural systems that might appear to deploy similar architectural elements or forms.[15] On the showfront, architectural elements and forms recur, or are borrowed, bodged and changed, very quickly, to the extent it could be argued that it is the systems that recur, not the forms. Despite this possible reversal, it is the logic of the surface system that remains important to both discussions, and where Semper's theory operates: 'Semper's work dissolved the distinction between structure and ornament. The wall was given an integrity that came from its definition in terms of the effecting of spatial enclosure while at the same time locating that realisation in the operation of materials' (Benjamin 2006, 23). This integrity is underwritten by the generosity, the 'narrative stickiness' to recall Chestnova's term, of *Stoffwechsel*. This logic also means that overall form is not required to understand instance: every section can produce effect: 'A singularity is always the after-effect of a relation ... Meaning ... is always the after-effect of the way materials work' (Benjamin 2015, xv–xvi).[16]

Across these various and significant changes in the material production of frontages, the deployment along the fair-line of the rides and attractions so produced demonstrates a consistency of surface-boundary logic. In the high art and high architectural examples that he analyses in detail, Benjamin is able to assert that their surfaces or walls assume an autonomy (within the architectural system or logic at play) with an 'internally regulated system of activity' (Benjamin 2006, 23) rather than bearing symbolic meaning. In contrast to this autonomy, the changeable, multiple-authored surfaces that together comprise the surface-boundary of the fairground give themselves up to a different, but equally strong, space-making role, one that bounds the fair as an autonomous space or activity and separates it off from the urban and everyday. The fair-line and the showfronts arranged along it are beholden to a different set of rules, a different economy, than Benjamin's architectural examples: it generates surface effects that affect atmosphere. Although perhaps less overtly concerned with the strict operation of systems than architecture, and much more on a phenomenological and atmospheric address to individuals and crowds within the fair itself, the surface gathered along the fair-line can be understood to pursue, amplify and supplement the logic of the individual good frontage. Along the fair-line, surface effect affects the circumscription of the fair and a separation from what lies outside, supporting the somatic and visual absorption of punters at two scales: bodily and building. The overriding organizational logic of this surface is to filter out or scramble information from the outside, rather than attempting the total isolation epitomized by the white wall and the silent system. This circumscription is at once effective and illusory and will be discussed in greater detail in the next two chapters.

NOTES

1. Theodor Adorno seems to offer some succor for Semper's loneliness here when he concedes 'Ultimately, perhaps, even carpets, ornaments, all non-figural things longingly await their interpretation' (Adorno [1970] 1997, 128). However, the broader context of Adorno's apparent interest in carpets hovers around the 'demarcation line between art and non-art,' and he clearly wants to situate carpets and ornaments on the far side of this divide. While this does not admit that they cannot be considered in terms of truth content and authorial intent, Adorno implicitly dismisses any such work of interpretation as fairly frivolous.
2. Evans cites Demetz and Blouet (1837) (See Evans [1971] 1997, n.19, 53).

3. Auburn Prison was opened in 1818. In 1831 Gustave de Beaumont and Alexis de Tocqueville were sent by the French government to study the new American prison systems, including the Auburn System. On their return, they completed *On the Penitentiary System in the United States and Its Application in France* (1833).
4. Key here are Braithwaite (1968) and (1975), Weedon and Ward (1981), Toulmin (2003), Jones (1951) as well as numerous publications on the histories of individual rides and attractions.
5. Josie Kane describes how 'Bioscope shows, often with capacities of over a hundred, remained a popular element of travelling fairs until the First World War, enticing crowds with ornately decorated fronts, blasting organ music and professional paraders' (Kane 2013, 100).
6. Eric Brown describes the waxing and waning of the Bioscope show, which peaks as 'a grandiose front with organ, top-hatted or be-spangled paraders, and clanging brass bells, showing now lost and forgotten French and English experiments in cinematography, [which] added its spectacular elevation to the temporary city. Commencing as a modest "walk-up" show, with a centre stairway, flanked on one side by the organ and on the other by an ornate and immaculate traction engine, and concealing behind its front a canvas booth, the later versions had an overwhelming central organ … After the short but illustrious lifetime of these fronts, the Cinematograph Acts and the construction of the "Electric Palaces" and "Cinemas de Luxe" around 1910 put an end to the travelling show, the fronts disappeared' (Brown 1945, 50).
7. Howell also notes how 'This not only speeded up the painting process, but also gave the customer [i.e. the showman buying the ride] a wider choice of decoration at a price that was competitive' (Howell 2003, 38).
8. Of course, there were exceptions, including some rides that adopted the latest architectural styles, such as art deco Waltzers, or the wholesale rebranding of amusement parks such as Blackpool carried out by architect Joseph Emberton during the 1930s. For more on Joseph Emberton, see Ind (1976) and (1983).
9. 'The collapse of authentic folk culture caused by the intrusion of foreign practices is marked by the loss of whitewash' (Wigley 1995, 8). The *Law of Ripolin* has its own origin myth, where the loss of originary folk architecture and culture is marked by the loss of white walls: see Le Corbusier ([1925] 1987). According to this law, 'Every citizen is required to replace his hangings, his damasks, his wall-papers, his stencils, with a plain coat of white ripolin' (Le Corbusier. [1925] 1987, 188). Coincidentally perhaps, just before this pronouncement, Le Corbusier notes the 'important statement' given by the Paris Fair in favour of this new morality. See also Batchelor (2001, 21–50).

10. In a separate work, Wigley discusses the complex phasing and visibility of technological changes as these become manifest around us: 'Giedion's argument that the everyday environment is always produced by the latest technologies is accepted [by McLuhan, Banham, the Independent Group and so on] but to this is added the key idea that the everyday environment is itself always invisible. What is visible is the environment produced by the previous technologies. The content of each new environment is the previous one. Each technology remembers the previous one by turning it into art' (Wigley, Mark. 2000, 58).

11. *Stoffwechsel* translates very roughly as the metamorphosis of materials, a change in (internal) state.

12. In the Orton and Spooner Collection, National Fairground and Circus Archive, held at the University of Sheffield (178H8.15): Emil Braun, *Vorschule der Kunstmythologie* (1854); George Hirth, *Formenschatz der Renaissance: Eine Quelle der Belehrung und Anregung für Künstler & Gewerbtreibende wie für alle Freunde stylvoller Schönheit aus den Werken der Dürer und Holbein [et al.]* (1877); Paul Rouaix, *Les Styles,* (1879); and H C Wolf, (Editeur), *Paris Exposition 1900* catalogue containing '47 Views of the Exhibition and of Paris' (1900). (The copy of Rouaix's *Les Styles* belonged to W. G. Hilton, an 'Architectural and Ornamental Wood Carver,' Burton on Trent, who worked closely with Orton and Spooner.)

 Pullouts include Sir William Chamber's Treatise (on *Civil Architecture*) [1759], showing the Tuscan Order for columns and arches, 'Published by the Proprietors of the Building News, 1860'; the reproduction of an etching of Erfurt Cathedral by B. Mannfekd from 'The Building News' (March 11 1892); a drawn façade of 'Organ for St. Alban's Church Teddington' by A H Skipworth, Architect from 'The Builder' (1 June 1895); and photographs by Captain J. Orr Ewing 'At the Paris Exhibition,' from the 'Supplement to the Illustrated London News (May 26, 1900).

13. Following the spirit of plundering and collaging from the past that is witnessed on the showfronts, Father Greville copied this passage from Rainsley (1946, 28). This is far from an isolated incident of plagiarism within Greville's various texts.

14. As in other areas of contemporary life, ersatz 'classic,' traditional or retro objects are now available, making it difficult at first glance to distinguish between an 'authentic' set of gallopers or a Waltzer, for example, and a recently manufactured 'classic' ride.

15. See Benjamin (2008, esp. 15–9) and Kaufmann (1955).

16. This suggestion offers an interesting point of reconnection to the work of Avrum Stroll, for whom surfaces always elude full comprehension. This connection will be explored in more detail in Chaps. 6 and 7.

Truth to *Trompe*, Theatre, Spectacle and Illusion

Abstract This chapter examines various 'exceptions' that were made by architectural theorists of surface, particularly Semper and Ruskin. Focusing on the *trompe-l'œil* or 'imitation,' which is frequently dismissed as unworthy of serious thought, the discussion of surface effect is broadened to consider theatricality, crowd experience and the provision of, and engagement with, illusion along the fair-line. It examines the tensions that illusion introduces between the body and the intellect, and how the good frontage might generate and sustain such tension. The chapter also discusses the contribution illusion makes to fairground atmosphere with reference to the work of Gernot Böhme, and the consequences this has on the unified subject or split spectator.

Keywords Ruskin • Semper • Carnival • Gernot Böhme • Perceptual doubling • Spectatorship

Canvas banners, carved wood, moulded fiberglass and various painted, airbrushed, vinyl transferred and aluminum dibonded flats: across the variety of material, decoration and relative size of the showfronts described in the previous chapter, the surface treatment—and surface effect—of the good frontage is not determined by its substrate or supporting material. This is in marked contrast to the approaches promoted by more conventional architectural discourse concerning the building surface or façade,

© The Author(s) 2018
S. Walker, *The Fair-Line and the Good Frontage*,
https://doi.org/10.1007/978-981-10-7974-0_5

where there has been a predominant line of argument that valorizes a certain 'truth to materials.' In addition to a certain illusory dynamic that was characteristic of *Stoffwechsel*—the translation or metamorphosis of decorative effects from one material into another—analysed above, the composite surface of good frontages along the fair-line forms a surface-boundary-limit with a slightly different operational logic of illusion, involving more active trickery and deceptive spatial effects, that is a key characteristic of and device in establishing the separation of the fairground from its outside.[1]

Perhaps this does not come as a surprise: trickery and illusion are central techniques of the fair and central to our expectations when we visit (indeed, arguably one of the reasons why we go). By association, we perhaps expect other aspects of the fair to reveal less than the whole truth about themselves. This chapter will discuss the interplay between truth and illusion, tracing a number of tricky issues from the surface effects that operate along the fair-line, and touching on theatricality and spectacle, on 'ways of seeing' and the emergence of the split spectator as a broad replacement for the unified subject that was increasingly challenged during the nineteenth century.

It is interesting to note that despite their other differences regarding their conceptions of the origin and role of surfaces, both Semper and Ruskin admit the potential of illusion in certain circumstances and with certain qualifications, particularly concerning surface illusion and theatre. Late on in his essay on 'The Four Elements of Architecture,' Semper introduces one exemption from his advocacy of the adherence to the original meaning of the wall (as a spatial enclosure) when he gives permission for surface manipulation to effect spatial tricks and distortions: 'it is always advisable when painting walls to remain mindful of the carpet as the earliest spatial enclosure. Exceptions can be made only in such cases where the spatial enclosure exists materially but not in the idea. Then painting enters the realm of theater decoration, which it often may be able to do with good results [such as the optical elongation of a courtyard by paintings on the boundary walls of the property, a popular move in northern Italy]' (Semper [1851] 1989, 127). Coincidentally, Ruskin also reluctantly made an 'exception' in his manifesto for *Modern Painters*, when he discusses the *trompe-l'œil* or 'imitation': for the conceit of the *trompe-l'œil* to work, it must reveal itself, so that the spectator can enjoy the frisson of moving from illusion to reality. Ruskin, against his better judgement, sets out how the *trompe-l'œil* gives pleasure from the discovery of a falsehood rather

than a truth, which provides a 'pleasurable surprise, an agreeable excitement of mind, exactly the same in its nature as that which we receive from juggling' (Ruskin [1843] 1903, 100).[2] As with Semper, Ruskin too offers an exception to his broader dismissal of imitation in art when he excuses the 'art of the diorama, or the stage.'[3] As with Semper, Ruskin articulates his qualified interest in imitation around the distinction between the material and the ideal: 'The difference between ideas of truth and of imitation lies chiefly in the following points: First,—Imitation can only be of something material, but truth has reference to statements both of the qualities of material things, and of emotions, impressions and thoughts' (Ruskin [1843] 1903, 108). Ruskin in particular, good Victorian that he was, did not want to dirty the realm of truth: indeed, Caroline Levine has noted how Ruskin 'condemned such self-reflexive display' that illusion involved, and 'insist[ed] that we refuse the seductions of trompe-l'œil in favour of a celebration of truth in art' (Levine 1998, 367).[4]

Ruskin protests too much: his is a moral objection, rather than one based on the capacities or operations of material and ideal truth. Semper's protests that spatial tricks and distortion can only operate with an idea-free materiality are later muted by his invocation of the carnival: 'Every artistic creation, every artistic pleasure presupposes a certain carnival spirit, or to express myself in a modern way—the haze of carnival candles is the true atmosphere of art' (Semper [1860–63] 1989, 257).[5] The caricature of the carnival and the fair associates them simply with material excess and hedonism. Even Angela Carter argues that 'the fun of the fair is entirely sensational—that is, a direct, visceral assault on the senses—and may be experienced cheaply and without guilt; it has no connotations ... which [are] all in the mind, but ... is all in the flesh and blood ... Fun is pleasure that does not involve the conscience or, furthermore, the intellect' (Carter [1977] 1997, 342, 341). Carter's apparently bald assertion is plucked from a section of writing where she contrasts definitions of fun with those of pleasure and delight (which both involve the mind). Nevertheless, it is typical of many attitudes that dismiss the fair from serious consideration because it is apparently a mindless pursuit. Broadly similar accusations have been made against other environments designed for fun or pleasure— the garden, the grotto, the circus—and against the deployment of similar 'sensational' techniques, magic, masking, *trompe-l'œil* and other illusory devices. No one has done more to counter this misreading than Peter Stallybrass and Allon White (1986): a closer account of their work is beyond the scope of this book, but their warnings can guide a qualified

consideration of Carter's assertion, and a qualified link to be made between this, Ruskin and Semper's various 'exceptions,' and the work of the fair-line. If it is (still) arguably possible to enjoy the fair sensationally, this is in part because of the work of the fair-line, the surface-boundary illusions it organizes and the atmosphere it helps to generate.

Gernot Böhme's work on atmospheres was introduced in Chap. 2. For Böhme, atmospheres are intermediate phenomena operating between subject and object, people and world. In contrast to the clear distinctions that emerge in Ruskin and Semper, where exceptional illusions are linked (albeit in different ways and with different motivations) to an idea-free materiality, Böhme lingers within the 'incomprehensible' atmosphere, and refuses to dismiss this as a mindless effect, even if it does seem to escape the intellect. His argument is worth quoting at length:

> The creation of an atmosphere through the character of materials can indeed be called magic. What is magic? Conjuring, telekinesis, the triggering of effects through signs. Magic is puzzling, it is incomprehensible ... Most remarkable and incomprehensible of all is how this effect can be had through mere appearance, i.e. through materiality without material ... The effect is deep and subcutaneous, as a rule even unconscious. Only afterwards, when we already feel a certain way in a space, when the atmospheric effect of the materials has already completely bewitched us, do we perhaps try, irritated, to identify its origin. This is what is eerie and dangerous. The same is true for the social character of materials. (Böhme [1995] 2013a, 98)

Böhme's concluding paragraph discusses the socialization process and our individual body's 'education' during childhood, which involves gathering up a kind of foundation for perception of things at a distance through early touching (Aristotelian *haphe*). While this process guides perception and navigation in the everyday world, it also underwrites spatio-material illusion. Although these illusions can be understood (after the fact), Böhme advocates the importance less of the understanding and more of the experience: 'The magic of the material is disclosed, even if we inevitably fall for it again and again. And why not? How impoverished life would be without this element of everyday regression' ([1995] 2013a, 99). Instead of ushering us away from these childish, regressive, illusory experiences the way Ruskin does, Böhme dwells on their importance. Here again, Böhme makes explicit reference to the same kinds of theatrical practice as Semper and Ruskin. 'Materiality can certainly be used to make magic. Designers, interior decorators, set designers do it' ([1995] 2013a, 99).[6] To which could be added, Showmen do it.

Böhme's relevance here concerns the operation of surface effect along the fair-line, particularly concerning these issues of illusion. Nevertheless, it should be noted that Böhme is explicit in his intention to expand the relevance of this experience and its operation beyond these particular, contained spatial encounters. In several works, he stresses his belief that the stage set provides a paradigmatic example of more general atmosphere creation, experience and understanding. This more generalized application has been challenged by several thinkers, notably Mark Dorrian, who voices disquiet at this transfer because of the particular modality and distance it expects on the part of the (passive) spectator: naturalizing atmosphere in this way comes at the expense of socio-cultural ingredients and dynamics (Dorrian 2014).[7] The fairground and theatre are highly aestheticized—mediated—environments, yet Böhme draws on these examples to develop his primary notion of atmosphere that he then extrapolates and generalizes to many other, ordinary situations. As spectators at the theatre or punters at the fairground, we're discouraged from exploring the machinations of the illusory apparatus, but this passivity and absorption should not be so easily extended to more everyday environments. Indeed, in a subsequent work, Böhme appears to draw back from his stage-set model, acknowledging 'In fact, the paradigm of the stage set actually entails dangers for architecture,' only to then reinvigorate it and to advocate this more strongly to planners as a lens or device with which they can 'enlarge [their] perspectives and possibilities' (Böhme [2008] 2017, 79).

I will return to these broader architectural surface discussions in Chap. 7. For now, it is sufficient to note this qualification, and return to the relevant contribution of Böhme concerning atmosphere and illusion. Indeed, Mark Dorrian has recently drawn attention to areas of philosophical and architectural thought that are challenged and developed by Böhme, noting how his work

> mobilises [the concept of the "ecstasies of things"] against the conventional philosophical understanding of the closure and passivity of the object. Now, through their ecstasies—thought of as forms of presence—things extend beyond themselves to produce effects in complex relational interactions with other entities. The idea entails a "principle of excitation," and it is an important notion for architecture—it gives us a way of articulating the effects of constellated things and, as Böhme would say, our atmospheric competence in interacting with them. (Dorrian 2017, xi–xii)

While there are clear differences between the particularities of individual and composite showfronts and the façades of buildings, their production of

surface effects do perhaps have more in common than is comfortably acknowledged. Rather than accepting the 'exceptional' status of magic, illusion and theatricality, which allows the materiality of these examples to be held apart, a reconsideration of theatricality can go some way to counter the clear categorical division within Semper's theory. Indeed, on Wigley's account, the logic of Semper's entire argument rests on illusion, or masking. 'The textile is a mask that dissimulates rather than represents the structure. The material wall is no more than a prop, a contingent piece of "scaffolding" that is "foreign" to the production of the building ... As [Architecture's] origin is dissimulation, its essence is no longer construction but the masking of construction' (Wigley 1995, 12).[8] At precisely this point, Wigley also links this originating dissimulation, or magic, to the emergence of the bounded individual, the institution of the family and the possibility of the larger community. (Aspects of this discussion concerning subjective interiority, domestic and social space will be picked up in the following chapter, where the bounded 'interior' space of the fair will be explored.)

Wigley is quick to link Semper's account of architecture's essence to the play of signs and the emergence of language. Gevork Hartoonian's more recent work on Semper enjoys a similar connection, but Hartoonian positions the potential theatrical aspect of Semper's work more centrally in his analysis than does Wigley. Referring to Semper's 'tectonic of theatricality,' Hartoonian argues that 'Semper moves in between border lines separating theatricality from theatricalization, to deny material through the embellishment of material itself' (Hartoonian 2012, 46).[9] Going beyond a casual connection between theatricality and spectacle, the broader concern here with illusion can be developed by reaching further back into history, to Aristotle's theory of theatre set out in *Poetics*. Although (understandably enough) most considerations of this work are anchored by a concern with the poetics of tragedy, its six key components, their hierarchy and inter-relationships, arguably anticipate Ruskin's momentary, exceptional illusion, and the rationale for its ultimate dismissal in his theory. The six components range in significance from plot [*mythos*], the most important, to the least, spectacle [*opsis*] and melody [*melos*], though these are frequently flattened into a more oppositional dynamic between word and image, or thought and material. Aristotle attempts to elevate the poet's art above material effect: 'To create this effect through spectacle [*opsis*] has little to do with the poet's art, and requires material resources. Those who use spectacle [*opsis*] to create an effect not of the fearful but only of the sensational have nothing at all in common with tragedy, as it is not every

pleasure one should seek from tragedy, but the appropriate kind' (Aristotle 1995, 1453 b 14, 73–4).[10] What is more important in the present context—and more frequently overlooked in accepted readings of Aristotle—is that the compound effect of all six components was intended to lead to *katharsis*, balancing or controlling sensual and intellectual effects, rather than synthesizing or overcoming them. Andrew Ford argues this point with reference to a particularly relevant example: 'A common pleasure [one available in the theatre to the "meanest tanner and the noblest philosopher there"] cannot be a very high pleasure, and *katharsis* is a strongly emotional rather than intellectual response' (Ford 1995, 121).[11] Moreover, Ford's conclusions also present a surprising claim concerning Aristotle, again reinforcing the enduring ambiguity of *katharsis* and its address to the base rather than elevated registers. He argues that for Aristotle, 'public theatres seem to be good for a city in a way more like a system of sewers than like museums' (Ford 1995, 124).[12]

Without getting drawn into the detail of these debates, the relevance of this Aristotelian detour lies in the ambiguity of this balance, where *katharsis* operates between spiritual/intellectual and physical/material registers. Although Ruskin could reluctantly accept similar mimetic ingredients in the particular presentation of spectacle [*opsis*] that is *trompe-l'œil* or imitation, this was only because he relied on the superiority of the intellect to recognize truth and thus police such an experience away from illusion and towards 'reality.'

Notwithstanding the similarities between the 'exceptional' examples they held in common, Semper was much more willing than Ruskin to accept a more fundamental ambiguity of surface qua spectacle [*opsis*], noting a key difference between surface appearance and material presence, and the way in which surface becomes non-compliant with straight material presence. Indeed, Semper famously countered the prevailing valorization of an architectural history that told of pure (white) marble classical architecture, asserting instead (based on his earlier work on polychromatic architecture) that the ancient Greeks had chosen white marble because of its 'moderate hardness, fineness, and uniformity of texture [which] lent itself to the most perfect finish treatment and was very durable at the same time [and] because it made the stucco coating superfluous. On marble temples the colouring could be applied directly' (Semper [1851] 1989a, b, 98). But Semper goes on to argue against attitudes based on the simple replacement of a materialistic understanding with a decorative one, stating that this can cause us to 'overlook ... the most important influences on the

development of art: Architecture, like its great teacher, nature, should choose and apply its material according to the laws conditioned by nature, yet should it not also make the form and character of its creations dependent on the ideas embodied in them, and not on the material' (Semper [1851] 1989, 102). Moving architecture away from the firm grip of the laws of nature opens it to the play of 'dissimulation' that commentators frequently observe in Semper's theory, where surface is not faithful to materiality or to internal structure. This also gives licence to the process of *Stoffwechsel* discussed in the previous chapter, the imaginative translation or metamorphosis of decorative effects from one material into another. The logic of this dissimulation could reach so far as to include Semper's exemption for a 'spatial enclosure [that] exists materially but not in the idea,' a dissimulation that operates in terms of more active trickery and deceptive spatial effects. For the observer in this particular case, the effect could sustain a *kathartic* ambiguity.

In Levine's upbeat reading of Ruskin's ideas (more upbeat than he allowed himself, that is), a *trompe-l'œil* 'always compels us to focus on the blurring and confusion of boundaries' (Levine 1998, 371). Levine gets to her main point by suggesting that this boundary confusion sets up (and sustains) two modes of looking within the observer, internally dividing them, allowing delight in their own perceptual doubleness. When Ruskin was writing, he could just about hang on to the notion that the *trompe* could provide a harmless—albeit untruthful—distraction like juggling, a momentary step away from the unified subject. However, as the fairground industrialized and modernized around the turn of the century, it offered a very different experience, one that would increasingly challenge the long-accepted, unified whole subject and its accompanying self-identity, which was coming under increasing pressure with the onset of rapid industrialization and modernization. Reassured, perhaps, by safety in numbers, or by an assumed bravado, visitors to the fair would experience and perhaps enjoy the phenomenon of doubling or multiplicity that increasingly accompanied modern urban life. While many 'good frontages' individually deploy and enjoy what Ruskin condemned as this 'low and vulgar' art form of illusion (*trompe-l'œil*), the composite surface of 'good frontages' along the fair-line forms a surface-boundary with a slightly different operational logic of illusion, one that calls into question the separation of the fairground from its outside. What is particularly relevant in this context is the resonance of Levine's analysis with the doubling or multiplicity that occurs in the punter's encounter with the boundary.[13] The doubling here

does not directly align with Semper's notion of a boundary that is formed through the surface-making effects of enclosure (spatializing), nor with Ruskin's distinction between an edifice (any edifice whatsoever) that supports an architectural adornment. Instead, it must be recognized as a composite surface operating at a large architectural or urban scale, with its own material actuality and its own mode of illusion based more on information scramble than on communication. Carter emphasizes the operation of this edge and the complicity of those crowded inside, who enjoy the underlying experience of parody rather than turning up for an *agreeable excitement of mind*: 'A fairground ... is visually a hard-edged world, in which most of the decorative detail is two-dimensional, executed in that kind of *trompe-l'œil* which deceives nobody and is intended to deceive nobody, not so much rococo as almost a conscious parody of rococo' (Carter [1977] 1997, 343).

Notwithstanding the material and decorative evolution—or *Stoffwechsel*—of the showfronts that were sketched out in the previous chapter, with the accumulation of rococo decoration that reached its excessive peak in the first third of the twentieth century, for reasons of practicality, the component parts of these showfronts had to be physically quite flat (Fig. 5.1). The many kinds of applied decoration (initially painted, then airbrushed and more recently applied in a two-stage process involving a vinyl transfer) on these individual showfronts operate to produce various kinds of illusion, including but not limited to the *trompe-l'œil* that Ruskin exercised . This has tended to be limited to the two-dimensional illusion of three-dimensional decoration, maintaining an impression of the appearance of rides and attractions from an increasingly distant era (see Fig. 4.7). As such, these *trompe-l'œil* played a secondary role in the overall visual impression provided by stall frontages, where far more area, and greater locational prominence, was (and continues to be) given to an illusion of another kind: an illusory, wildly exaggerated promise of the entertainment purveyed within the attraction or on the ride. At least in intention, good frontages offer (in different degrees) illusion twice over, a double dissimulation, one mediated and immediate (the *trompe*) and one delayed (the groundless promise of entertainment or spectacle that involves moon rockets, supersonic aircraft or racing cars, or that takes place in expansive deserts, in thick forests full of wild beasts, or in deep space).

Carter's specific point, that nobody is deceived by these surface illusions, holds not only for the *trompe-l'œil* decoration but can also be understood at the scale of the overall showfront and for the fairground experience

Fig. 5.1 George Orton, Sons and Spooner Limited design drawings, circa 1910 (Orton and Spooner Collection from the David Braithwaite Collection. Reproduced with permission from the University of Sheffield Library, National Fairground and Circus Archive)

more generally. With some earlier attractions and particularly with rides, the material surface of the showfront is interrupted with cutouts and voids that reveal the two-dimensionality of their material support, reveal spaces inside (a fairground space beyond the apparent fair-line boundary) or even reveal the everyday space of the world outside, now framed by or appearing within a fairground attraction. In these situations, the operation of the surface effect relies both on the strength of the spectacle and on the punter's willingness to succumb to the illusion. The bounding surface is itself an open illusion, understood as such but accepted and upheld by all (an emperor's-new-clothes complicity that does much to sustain the fairground atmosphere). The experience of doubling that this offers does not work along Ruskin's schema, it does not offer two ways of looking at an illusion (where the doubling involves the observer looking plus seeing themselves looking—with their mind's eye—and so 'getting it,' with the *agreeable excitement* this brings). Instead, it combines two ways of seeing the effect(s) of the same surface, two ways of looking that are different in kind, and thus brings about the experience of a mismatch between the abstract notion of a completely enclosed, autonomous space bound by a one-sided surface and the reality of an outside that intrudes (as well as seeing the material entities that mark this one-sided and two-sided boundary).[14]

To further complicate this balance, it is important to note that perceptual responses themselves are not static, natural or ahistorical. Focusing on the situation concerning the good frontage, there is a parallel between the material and technological evolution of showfrontages and the changes taking place in the spectator, their ways of seeing (to redeploy John Berger's well-known approach), during the same period, something that has been examined by Jonathan Crary. Crary links the historico-cultural construction of attention to changes taking place in human beings with the modernization of the Western world, changes contributing to a 'powerful remaking of human subjectivity in the West over the last 150 years' (2001, 1).[15] Crary's work not only supports a more detailed interrogation of how changing spectatorship was caught up in changes to the spectacle and culture of the fairground—the influence of technological developments on forms of 'spectacle, display, projection, attraction and recording' (2001, 2)—it also allows a backwards glance to the work of both Semper and Ruskin and particularly to the latter's reluctant engagement with illusion. Whereas Ruskin could accept the 'agreeable surprise' produced by illusion, he believed this could be quickly dismissed as a simple material pleasure. Crary's work allows this to be read as a certain anticipation of

'the problem of attention' that became powerfully demonstrated as the century progressed. Indeed what Crary traces is the increasing 'absurdity' of simple geometrical accounts of vision, and argues for the need to replace the 'coherent order of geometrical optics' (2001, 87) with a framework that could respond to the increasing complexities and incoherence of vision in the modern period.

Ruskin's optics belong to a different era, one increasingly unsettled by technological progress. Discussing Manet's work, Crary suggests that it figures 'the unfocused and disunified nature of perception … *nonconvergence* … It would be a diagram of a vision that had lost or abdicated a voluntary capacity to effect an optical convergence, a convergence without which a normal attention would be impossible' (Crary 2001, 105). This is the kind of dynamic that Ruskin worries about; for Ruskin to sleep at night, this 'exceptional' nonconvergence revealed by the *trompe-l'œil* had to be delimited, understood and explained away, or laughed off like a juggling display. With the longer view we are now afforded, it offers instead a premonition of what would happen (arguably, what was already happening) to a Victorian way of seeing, as this gave way to a new sensibility for a modernizing, industrializing age.

Crary is insistent on the need to exceed any conflation of modern spectatorship to looking, the geometrical-optical gaze and so on, pushing for a more complex understanding that is able to account more fully for the spectator's experience. The thrust of his analysis of the modern spectacle is towards a complex and ambiguous dynamic, one that resists resolution in an intellectualized moment of clarity when understanding transcends the material, social world. Considering Ruskin's explanation of illusion through this new optics highlights the Victorian's insistence on restricting the operation of the *trompe-l'œil* to a (deliberate) fault of convergent optics, underwritten by an associated 'whole subject.' The *trompe-l'œil* presents a static illusion that must be consumed more or less from a singular viewing position. With some physical movement, the illusory image is revealed as such because the viewing position of the spectator diverges from the convergent optics required to sustain the trick of the trompe. For Ruskin, this was a singular moment of trickery, an aberrant moment of disunification and nonconvergence that could quickly be put to one side when the observer realizes a three-dimensional spectacle to be in fact a two-dimensional scene, a realization that depends upon the material theatricality being overridden by the intellect. Crary's insistence is that the attentive observer written into Ruskin's theory was to be very quickly

replaced by an inattentive one, and that the priority of the intellect that underwrites the attentive observer is also challenged by the pull of the material, technical world. To this extent, Crary's account of the spectacle returns us to the various other re-readings set out earlier in this chapter: Ford's admittedly minority insistence of an ambiguous Aristotelian spectacle (*opsis*), Böhme's 'incomprehensible' atmosphere and Levine's Ruskinian boundary blurring, all of which work to insist on the enduring ambiguity of the various illusions or spectacles they examine. Taking these seriously, it becomes impossible to dismiss or circumscribe instances of surface ambiguity, illusion and so on: they are inherent in surface effects and cannot be delimited in small examples (trompe) and forgotten about. Moreover, taking these seriously challenges fundamentally the more classical notion of a visually cohesive field within which perception can be comprehended. They do not simply replace this coherence with its opposite, but demand a different framework within which cohesion and the radical challenge to that cohesion co-exist in various degrees of tension that are a product of the constitution and context of a situation. Maintaining a focus on the good frontage of the fairground, the specificities of this tension in the visual field, and its relationship to the material and surface effects of the frontage, rehearse a particular version of this broader relationship.

A straightforward view of the frontages arranged along the fair-line immediately challenges any claim that this could provide a visually cohesive field for the fairground. Although these surfaces are often physically and materially discontinuous, more than most other architectural surfaces, in this context the surface effects of the materials so assembled do operate to encourage punters to grant the fair boundary a visual coherence. Angela Carter's frank reminder can be reapplied to this larger scale of consideration: any claim to visual coherence *deceives nobody and is intended to deceive nobody*. Although Crary's thesis is that attention could no longer survive as the normative mode of perception once modernization took hold, he acknowledges that attention still has a role to play 'holding together' the disparate stuff of the modern world, guarding against 'various kinds of sensory or cognitive breakdown' (Crary 2001, 91). Particularly at the fairground, there are multiple demands on the sensory reception of the punters, simultaneous and complex calls for attention that also inscribe tricks, illusions and moments of absence that also operate if not against, then certainly to breakdown the clarity of such calls.

Although circuses and fairs must not be conflated in their histories or the spatiality of the spectacles they offer, it is interesting to consider Crary's discussion of *Parade de cirque* (1887–88), Georges Seurat's pointillist depiction of the *parade* set up by the Circus Corvi at the annual Gingerbread Fair in Paris, because the architectural arrangement and role of the *parade* have much in common with that of the good frontage. Although *parade* is frequently translated as 'sideshow' in English titles of this painting, this is slightly misleading. The role of the *parade*, as well as its architectural relationship to the circus it was promoting, is far closer to the good frontage in its operation than is suggested by 'sideshow.' (Indeed, the architectural arrangement and language of the *parade* is very close to fairground frontages of the same period.) The *parade* was set up adjacent to the Corvi circus tent, and as Crary describes, it was a 'device of *attraction*, meant to focus the attention of urban strollers and to persuade them to buy a ticket for access to the "main" attraction' (2001, 187).[16]

Crary's interest lies in the modality of perception offered or demanded by that spectacle: he describes how the surface of Seurat's painting 'mak[es] impossible a punctual, or point to point, relation between spectator and image … *Parade de cirque*, then, hovers ambiguously between two scopic regimes, to use Martin Jay's phrase: between the metric and homogeneous tableau loosely synonymous with classical space, and a decentred and destabilized perceptual regime with its mobile and embodied observer. The evocation of a scenographic setup is a veil over the dissociated, nonhomogenous, and additive construction of the work' (Crary 2001, 188–91).[17] The scenographic conceit of the painting's composition and pointillist execution has an echo in many of the showfronts, which (particularly around the turn of the century but continuing in many shows and rides to this day) in part are organized as a kind of proscenium framing that presupposes or prompts a static spectator or collective audience, addressed by barkers as an animating impresario. Spectators are potential punters and are encouraged to watch the spectacle but then also to break this boundary by passing through the proscenium to take a turn on the ride (and pay for the privilege).[18]

Into to the 'metric and homogenous' regime of classical spectacle, the various modalities of illusion are added by the surface effects discussed above, such that the classical space and spectatorial viewing relationship are both set up and disrupted by the showfronts: set up at the overall scale of the single frontage-as-proscenium and disrupted by smaller-scale *trompe-l'œil* decorations, by medium-scale panoramic panels and by

irregular voids and breaks in the material surface effects permitting partial views into the ride space, views through to and beyond the 'other side.' In addition to these dissociations brought about by complex and nonhomogenous, additive surface effects, the physical relationship between spectator and stage expected by the conventional proscenium arrangement is also disrupted by other activities within the fairground: for example, other punters pass within and through a crowd of spectators captivated by a particular attraction, and other noises from multiple other sources interfere with the straightforward theatrical relationship. This would not be dissimilar to the interference experienced on the *parade*, although there the conflict would have been between a (momentarily) static audience considering the offers or claims of the circus impresario and the 'urban strollers' moving along the city streets.

These various doublings—double movement, double spatialities, double readings and so on—happen along the whole fair-line and at smaller scales within it. This situation can be willingly misread as coherent (Carter), or taken to be obviously flawed or destabilized from within its bounding surface by small-scale *trompe-l'œil*, as well as through and around its edges by the intrusion of other spaces, the everyday architecture of its surroundings. Rather than following a Ruskinian line to suggest that the showfront operates this doubling or destabilizing between truth and illusion, the good frontages, both individually and arranged as a composite to produce the bounding fairground surface, knowingly operate between abstractions and physical entities. This pushes the modality of deception away from Ruskin's preferred explanation, so that it becomes less a concern with seeing the whole or the part, and (following Ruskin's account in the opposite or 'wrong' direction) more about potentially seeing the showfront from various points of view more or less simultaneously or sequentially. The showfront maintains ambiguity and avoids full resolution, between sensory and intellectual responses.

Notes

1. Robin Evans discusses an interesting counter-example to the particularities of the *trompe-l'œil* discussed in this chapter, where the physical presence of objects within a space was deliberately distorted and flattened onto the surface of the design drawings for those spaces. 'It is a painterly architecture that compares with the developed surface, intent on illusion, but it is not the illusion of *depth* that is sought, it is the illusion of *flatness*' (Evans [1989] 1997, 210). Evans is interested in these rooms as they become detached from an overall compositional logic of sequence that characterized previous stately

homes: in his example, individual rooms were to be experienced in 'any' order, and each one was to be a surprise: not unlike the spaces or attractions at a fair.

2. This is part of a sequence of chapters determining the kinds of ideas that can be received from art (Power, Imitation, Truth, Beauty, Relation), an approach that is echoed in his *The Seven Lamps of Architecture* [1849], which includes the Lamp of Truth (II), of Power (III) and of Beauty (IV).

3. Ruskin generally condemns the artist who produces illusions, arguing that they only possess qualities 'of moderate industry… [in] no degree separate from a pin maker or other neat-handed artificer,' but then immediately adds 'These remarks do not apply to the art of the diorama, or the stage…' (Ruskin [1843] 1903, 103).

4. Levine writes of the 'double, ironic experience of the trompe-l'œil' and of 'its reputation as a low and vulgar art form' which she wants to defy, arguing that it reveals something important about our involvement in the dynamics of spectatorship.

5. The full English text is Semper ([1860–63] 2004).

6. Böhme's final analytical section takes as its example 'the theory of garden art, more exactly the English landscape garden or park, as it is presented in the five volume work of Hirschfeld' (See Hirschfeld 1779–1785), and which is akin to theatre design.

7. In this article, Dorrian discusses in particular Böhme's 'The Art of the Stage Set as a Paradigm for an Aesthetics of Atmosphere.' See Böhme (2013b).

8. Elsewhere, Wigley remarks how Semper isolates carnival as the only architectural or theatrical effect: for Semper, 'To construct architecture is simply to prop up a surface that produces an atmosphere … This hyper-charged surface actually wraps the atmosphere rather than the building. It is the outer visible layer of the invisible climate' (Wigley 1998, 20).

9. 'Central to the idea of theatricality is the communicative dimension of architecture' (Hartoonian 2012, 25). Although Hartoonian makes much of theatricality, he borrows the connection from Harry Francis Malgrave, who in turn —in a tale that could itself originate on the fairground—confesses that this term has (only) been applied to Semper's work once in the past by 'Professor Magirius.' Hartoonian contextualizes the focus of his consideration of contemporary architectural practice with reference to the longer history of architectural surface, and to familiar discussions of stage sets and carnivals, from which he distances architecture. This work is an update and slight expansion of his *Crisis of the Object* (2006).

10. Here, Stephen Halliwell's translation is unusual in its emphasis of the material contrast to the poet's art: the term is translated variously: as 'extraneous aids' by S. H. Butcher (Macmillan and Co. 1902), as 'adventitious aid' by W. Hamilton Fyfe (Harvard University Press, 1932) and simply as 'the production' by Malcolm Heath (Penguin Classics, 1996).

I am grateful to Maria Mitsoula for drawing my attention to the intricacies of *opsis* in both its ancient and modern Greek manifestations.

For an overview of the hierarchy of the senses in classical thought (and theatre), see Jay (1993) Chap. 1. 'The Noblest of the Senses,' esp. 21–33.

11. Ford admits that his is a 'particularly minority interpretation' of *katharsis*, that he 'hope[s] to complicate the modern search for a solution' (1995, 109).

12. This also has a certain resonance and challenge for Böhme, and his valorization of the theatre as the exemplary situation within which atmosphere is produced.

13. There are many other spectatorial doublings at the fair, of course, such as the turn-taking (watching others making fools of themselves, then taking part) as well as complex voyeurisms and illusions. Crary argues that the historical, carnival complexity of such swapping of roles remains legible in the fairground: 'we still get a tenuous sense of how the disorder of carnival overturns a distinction between spectator and performer, how it destabilizes any fixed position or identity' (Crary 2002, 8).

14. This situation is more akin (but not identical) to the optical illusions such as Rubin's Vase/Faces Illusion [1915], Poggendorff's Illusion [1860], the Necker Cube [1832], Hering's Illusion [1861] and so on, where vision science has recently used accounts of 'multistable' perception to characterize the conflicting readings that can be brought about by these visually ambiguous patterns where both (or several) logics can be identified but not held at the same time.

15. This work is an extension of his earlier book *Techniques of the Observer: On Vision and Modernity in the Nineteenth Century* (1990), which addressed an earlier period of modernity running from the eighteenth through into the first half of the nineteenth century, despite the suggestion of the title. *Suspensions of Perception* focuses mainly on the last 20 years of the nineteenth century.

16. On Crary (2001) page 188 there is a photograph showing a similar arrangement of a circus tent with a sideshow platform, taken in Paris during the late 1880s. The circus tent is as mute as the parade frontage is elaborate, repeating precisely the logic of the good frontage as Bostock expressed it.

17. See also Jay (1993, 149–210) 'The Crisis of the Ancien Scopic Régime: From the Impressionists to Bergson.'

18. This point has been made by several writers. Developing the observation in ways that relate directly to discussion in the following chapter, Stallybrass and White note 'the plebeian fair-goers were themselves part of the spectacle for the bourgeois observer. At the fair the subordinate classes became the object of a gaze constituting itself as respectable and superior by substituting observation for participation' (1986, 42).

CHAPTER 6

Spectatorship: The Panorama of the Whole

Abstract This chapter develops the questions of separation that is established by the fair-line by considering the fair as an inside without an outside. The experience of the fair as an interior space is traced with reference to other radically interiorized spaces developed during the nineteenth century such as world's fairs, expos and the particular case of the panorama. Momentary challenges to this interiority are provided by particular opportunities for spectatorship that are elevated above the horizontality, and the horizon, of the fair by rides such as the Helter Skelter and Ferris Wheel. These are discussed and contrasted with what De Cauter refers to as 'vertigo machines,' high-speed rides that offer elevation but no panorama.

Keywords Nineteenth-century interiors • Immersive experience • Vertigo machine • Overview • Ambulatory vision • Point of zero resolution

This chapter will move away from the particular effects and surface operations of the individual good frontages considered to be so important by Bostock and concentrate on the larger-scale effects and spaces produced within the fairground. This move in scale introduces a further ambiguity or complexity to those already rehearsed around the individual showfront. Andrew Benjamin, as with most people who review Semper's architectural theory, focuses on the external effects of architectural surfaces, albeit that these included the effecting of spatial enclosure. Benjamin is careful to

stress that the surface must not be conflated to the materiality of the wall, for reasons already covered in Chap. 4. In a passage of analysis that is unusual inasmuch as it explicitly addresses internal spaces, Benjamin suggests that the space-effecting operation here is somehow different from that taking place on the outside: 'On the interior, of course, the surface loses any simply generalized sense and becomes a locus of plural possibilities' (2006, 29).[1]

Now in addition to the various illusions, *trompe*, trickeries and suspensions of perceptual clarity discussed in the previous chapter, I want to suggest that along the good frontages of the fair-line, both these situations occur. The good frontage can be read as both an exterior surface and an interior surface: locus of specific space-generating qualities qua showfront and locus of plural possibilities qua interior fairground boundary. Indeed, if the boundary (in addition to, and as a special case of, the broad and varied menu of illusions and other physical extraordinaries made available for punters in the fairground to consume either as spectator or participant) operates as both and between physical boundary and a boundary illusion, what implications does this have, if any, for the experience inside? As punters, at least when the fair is in full swing, we not only feel enclosed by the fairground's boundary and atmosphere, we can feel removed from the everyday, surrounding space of the world. For the space of the fair, there is arguably no exterior. Considering Bostock's assertion (to the effect that the good frontage was conceived of without any real concern with what was inside or beyond), to posit the fairground as an inside without an outside becomes doubly interesting when the compound effect of frontages along the fair-line is considered. The plural possibilities that Benjamin notes can be linked to the operation of the single and compound frontage as a façade (at different scales), as a threshold (crossed in different directions with different levels of attention and scale), as limit (separating, in many cases very badly, the atmospheres of 'worlds' of the fairground and the outside) and as an attractor that operates with the promise of an illusory beyond that is still inside (the 'interior' of the fairground attraction, which for Bostock really was hidden, but has become increasingly revealed over the course of the twentieth century).

It is instructive to compare this enclosed space of the fairground with other large interiors that also emerged over the course of the nineteenth century. Although the fair as an event predates this 'emergence' by many centuries, the spatial effects under consideration here were produced by the introduction and development of the good frontages during this

century. Citing Walter Benjamin's list of 'arcades, winter-gardens, panoramas, factories, wax museums, casinos, railroad stations,' Georges Teyssot observes certain types of nineteenth-century space that provided vast interiors, indeed that were so vast that they denied the existence or importance of their exterior. These 'spaces are the containers of the crowd: they enclose the collective dream ... The nineteenth century in this sense not only offers a transitional moment but is characterised by transitional spaces. The public space becomes a threshold, a space that holds together or "contains" the flow of the crowd' (Teyssot 2008, 8).[2]

It is not simply the crowded condition of these spaces that renders them 'interior,' nor should their interiority or their crowds be taken as homogenous. Benjamin's list includes buildings for a wide range of activities. Making a partial selection from these, and supplementing them with related vast interiors—world interiors, to follow Sloterdijk's work on the Crystal Palace—including expositions and world's fairs, their interiorizing qualities can be compared to the enclosing operations of the fairground surface. In this selection, various modalities of crowd-based spectatorship occurred—the 'distinctly complex' pursuits of Cross and Walton's *playful crowd*—from contemplative to boisterous and everything in between, and involving individuals, small or large groups, or the whole crowd. Some of this vastness of interior and variety of spectatorship is a consequence of thematic zoning: for example, the compression of different referents for geographical and historical locations within world's fairs and expositions, or the referents for large-scale illuminations at Blackpool mentioned in Chap. 2. At the fair, this composite is produced less in terms of spatial zoning (the fair is much more an assortment on these terms, although other logics do dictate who can show where).

Notwithstanding certain content that they share (rides and attractions), the various phases and directions of exchange (free or otherwise) and overlaps or a certain disorientation they might bring about, world's fairs and fairgrounds take on their 'vast interior' qualities through very different mechanisms and dynamics. Fairgrounds are more reliant on the space-effecting operation of their boundaries, in contrast to the actual or notionally limitless horizon or contents at the world's fairs or expos. Indeed, from the 1851 Great Exhibition, world's fairs were linked together through their sheer size, whatever other lengths they went to in order to establish individual (usually nationalistic) character. As Darwin wrote in his Journal, there is too much to see. Nelson estimated the time required to get around all the exhibits at White City in 1908 to be three weeks (not

unlike the blockbuster art exhibition nowadays): there were 150 miles of display to cover (Nelson 1986, 110, cited in De Cauter 1993, 17).[3]

The sheer number of objects on display in expos was frequently noted, but the implications of the kinds of object that were brought together in the same event, and their consequent escape from any kind of classification system, are more interesting here. Mallarmé, for example, recounted his visits to the four London International Exhibitions (1871–74). Crary argues '[this] firsthand and clearly disorienting experience of a world's fair ... disclosed to him a smooth space on which the boundaries between the domains of art and industry had collapsed... [offering] a tantalizing surface of experience' (2001, 121–2).[4] Crary's gloss indicates the way that the overwhelming and disorientating experience (disorientation a product of being overwhelmed) was overcome by Mallarmé when he identified or established a notional horizon.

The nature of this experience, and with it the spectator, the mode of spectatorship and the nature of its associated horizon, changed during the second half of the nineteenth century. Echoing the changes that the fair had undergone much earlier in its history, shifting its principal activity from exchange and trade to 'consumption and instant pleasure,' the world's fairs similarly lost their 'serious' focus on science, on the prowess of industrialized production, and 'over the years ... became the laboratories of exoticism, tourism and consumerism' (De Cauter 1993, 14). The experience of this change was accompanied by an increasing temporal detachment between the experience within the world's fairs and their surroundings. Again Mallarmé recorded his dismayed response to the ceaseless turnover of new products at the international exhibitions (see Crary 2001, 119); this was an experience noted by many, including Walter Benjamin, who described it as 'empty time' or the spare time of consumption. This suggests a temporal corollary to the horizoned experience just noted, once the world's fairs or expos were entered: 'There is no continuity [with the outside], no past or future but a series of events that are "in" or "out"; ... The immediate time is the negation of duration, it is the creation of a big cluster of events as actuality' (De Cauter 1993, 11). There are some similarities here with the operation of the fair-line boundary that will be discussed in more detail below, but it is important to note that as the fair developed over the course of the twentieth century, it has counterbalanced its offer of novelty presented by the ceaseless turnover of experiences on offer, and now includes a significant minority of 'heritage' rides known to many from previous visits, from their childhood or from

beyond their own lifetime. Moreover, many rides take up the same plot year after year, a permanence that is written into the rules of the Showmen's Guild of Great Britain (SGGB).

These particular issues of bounding, and the various modalities of horizon experience involved, have been explored by Lieven De Cauter in ways that help the present discussion. De Cauter's conceit is to consider the panorama, as a specific, structured experience of horizon-gazing and as an enclosing architectural structure, as both a literal visit to the panorama and more metaphorically as a way of accounting for the vast interior of the world's fairs and expos. Transposing the experience of this device onto that of the world's fairs, De Cauter traces the changes that take place to the experience of those events, paying specific attention to the role of the horizon and how this is reformulated and eventually dissolved over the course of the twentieth century. De Cauter's steady conflation of the world's fairs and panorama supports an analysis that operates at the boundary, or more precisely the boundlessness, of the punter's visual experience. World's fairs, as already noted, had quickly become so extensive it was physically near impossible to pass in front of all the displays: in panoramas, although consumed from a more or less fixed viewing position (the spectator was mobile and expected to turn around, but more or less to turn on the spot, on a small viewing platform), the illusion provided was one of boundless space.

Although there is some dispute regarding claims made for the panorama's exclusivity in its symbolic attempt to control an internal space by manipulating the visible horizon, there are comfortable parallels with the world's fairs' establishment of a vast space, even a world interior, and it is clear that a certain illusion is in operation at the horizon in both cases. As Sonsoles Hernández Barbosa notes: 'According to Oetterman, the panorama, which had initially played a symbolic role that evoked the conquest of space by capturing the horizon, shifted now towards becoming an attraction, a change which was propitiated by technological devices and the enactment of new experiences' (Hernández Barbosa 2017, 9).[5]

This dispute was not simply over the representation of the horizon but more fundamentally as an exchange in the control over certain sublime experiences. Gradually moving away from the sublime transport in the face of the vastness of nature celebrated by eighteenth-century philosophers, and approached by painters around the same period, the panorama marked an attempt to wrest control over sublime experience away from nature itself and into an illusion of nature. The sheer scale of the 1851

Great Exhibition was sufficient to induce a certain sublime feeling of incomprehension: De Cauter traces the subsequent changes that took place to this quasi-sublime panoramic experience available within the vast interior, in parallel with various stages of the panoramic mechanism's attempts to provide seamless trickery, one that replaced the (sense of a) limitless view within a physically delimited space. The extent to which the paying spectators within a panorama were genuinely taken in by the illusion is a moot point: reports vary, but it is safe to say that for the illusion to work, a certain amount of indulgence on the part of spectators was required. Taking these observations to a consideration of the bounding surface of the fairground, and considering this boundary surface as a quasi-panoramic horizon, perhaps pushes credulity, as the fairground usually possesses neither the physical vastness of a world's fairs nor the integrated illusion of the panorama. But as Angela Carter has reminded us, the fairground illusion *deceives nobody and is intended to deceive nobody*: this deceit is only different in its extent, not in kind. With a willing crowd, the boundary surface of the fairground can operate just as effectively.

In its developed form, the panorama was 'no longer ... presented as a merely visual experience, but had to be fundamentally immersive and embodied' (Hernández Barbosa 2017, 4). Contemporary observers remarked on 'the unfathomable depth of the horizon, we are surrounded by infinity... and we have difficulty in believing that this impression of vastness without limits, is only brought about by means of a skillful but erudite art' (Faideau 1900, III: 313, cited in De Cauter 1993, 14). To establish and maintain this immersive experience, the threshold between the outside world and the illusory spectacle of the panorama was deliberately extended in order to control the transition between the two. 'All terms of comparison by which the eye could judge the difference between painting [shown in the panorama] and reality were excluded. The viewer, having become accustomed to the dimness of light in the purposely obscure corridor by which he entered, would emerge into the light of the viewing area to find that, by contrast, it appeared as bright as the remembered daylight outside' (Wilcox 1988, 20).[6] The ambiguity of this transitional threshold experience is repeated, using different means, in the threshold between the everyday world and the fairground. In contrast to the panorama and the world's fairs, where the entrance was marked and celebrated architecturally, few fairgrounds have any kind of marked or controlled entrance: instead, entry is made into the fairground via ambiguous, unmarked passages across the fair-line. For all its ambiguity, the

change between the two locations is unmistakable. Fairground atmosphere overflows its interior, its noises and smells can be partly sensed from some distance outside (thanks to increasing power of amplification and the increased use of large sound systems on some rides, the acoustic reach of the fair is significant, extending in some situations for a mile or more).[7] Even prior to electric amplification, the noise from fairground organs was remarkable: descriptions of Oxford St. Giles' Fair in the early years of the twentieth century note 'the sound of every kind of mechanical organ in glorious confusion' (Anon. 1923, 6) and how 'the steam organs and instruments are continually playing and cause the greater part of the din which drowns every other softer sound' (Muncey 1936, 100). In addition to this atmospheric spatial overflow, there are various temporal overflows beyond the fair provided through media build-up, including advertising posters announcing the fair's arrival, as well as official forewarnings of traffic diversions, road closures and parking suspensions.

In a curious inversion, the extended transitional threshold of the panorama opens onto a relatively small, enclosed space which is in turn denied by the expansive illusory spatial experience of the panorama, while the multiple, unremarkable thresholds of the fairground give onto an enclosure defined primarily by its horizontal boundary. Whereas various devices (such as canopies and oblique lighting) were used to prevent the illusion of the panorama from being interrupted by direct views of the outside world, or by shadows cast by other spectators, the spatial illusion of the fairground proves more robust (or the audience more forgiving), requiring no special effort to establish and maintain beyond the arrangement of the showfronts along the fair-line. David Braithwaite describes when

> open space becomes fairground a miracle is wrought, and a *tober* [the total environmental complex of the fairground] created... The fabric of the *tober* is self-transcending, insubstantial, but powerful in impact... But insubstantial though it may be ... a metamorphosis [is created] in terms of environment. The existing town pattern is forgotten and dreary surroundings are thrown into shadow as the dream intensifies. (Braithwaite 1968, 21–2)

Whereas most panoramic spectacles transported their enclosed audience outdoors (large landscapes and cityscapes were most common), the fairground offers punters something of an interior experience in the open air. Braithwaite's slightly overwrought account echoes and inverts Plato's warnings about the cave, an interior space whose surfaces were similarly one-sided. (Inverts Plato's missive for those inside to leave, that is.

Braithwaite's emphasis on the tober's insubstantial fabric highlights the limitation of this cave analogy in other respects.) In both situations, panorama and fair-line, Brian Hatton's meditation on cave walls is interesting: 'Lacking yonder-sides, they faced and enclosed, but did not divide space' (1999, 68). Pushing Hatton's point, the ambiguous threshold and the surface effect of the fair-line should not be considered to produce a division in existing space, despite all the evidence to the contrary, but to be productive of an enclosure with no outside. To cross the threshold into the fairground is to admit (oneself) to another space entirely, an illusory world which enjoys an ambiguous relationship to its certain physical location.

Discussing Frederick Keisler's *Grotto for Mediation for New Harmony* (1964), Naomi Miller touches on similar cave-like qualities in other spaces, emphasizing—in terms not unlike Braithwaite's—the enduring relevance of the grotto as a challenge to and an escape from the everyday: 'Keisler's rhetoric [on the grotto] is twentieth century, but his ideas connect with the ancients … A fancy, a capricious toy, it is born of nature and spun by art for delectation and delight … Perhaps like the proscenium of the theatre, the grotto is above all a metaphorical portal, an entrance, a place of passage. To enter is the significant act; for to enter is to acknowledge the distance between outside and inside, between reality and illusion, between nature and art' (1982, 123). Miller's reading here is relevant and awkward (particularly in her likening of the grotto to the theatre proscenium, recalling the difficulties of this example as a model for 'atmospheric' production discussed in the previous chapter). Entering a grotto or a theatre or even a panorama is usually considered an act done in isolation or small groups, but to enter into the fairground is to join the crowd. While the act itself is arguably just as significant, and the experience so gained is equally loaded in terms of reality and illusion, the operation of the fairground's horizon—its composite surface-boundary—can be seen to work in reverse, and this at two scales. Firstly, in contrast to the logic of the panoramic surface, discussed above as part of a broader intent to capture the horizon, the intention of the fairground's horizon is to capture and hold the punter and maintain the effect of an enclosure with no outside. Secondly, the 'audience' (although this term is hard to apply to the playful crowd of punters who are inside) is invited locally to re-cross the fair-line while remaining within the fair, in order to partake of the particular pleasures on offer within any one ride or attraction, a cave-within-a-cave.[8] (This is a specific instance of the more general situation that occurs on those rides or attractions located more deeply within the fairground.) These particular experiences

Fig. 6.1 Riders at Oxford St. Giles' Fair passing close to the cornices of adjacent buildings, 2012 (Photograph, Stephen Walker)

take place 'within' the fair but physically 'beyond' the fair-line. For the punter, the distinction is frequently unimportant (although there are tense moments when contact is temporarily regained with the everyday surroundings, contact that often seems physically to be too close for comfort such as that shown in Fig. 6.1). Even in these 'exceptional' situations, the overall consistency of the fairground illusion, and separation, is maintained.

More interesting exceptions occur when the horizontal relationship is disrupted, whether the dynamic of this relationship is for the spectator to capture the horizon, as in the panorama, or to be captured by it. The fairground generally tries to prevent punters gaining a clear and coherent picture of the environment, to prolong the atmosphere and thus prolong the time punters will potentially be spending money. In contrast to the construction of the panorama, which provided a fully enclosed and controlled illusion within a space approximating to a hemisphere, the illusion of the fairground as an entirely other space is only constructed by a horizontal band of showfronts. Within this horizontal space, the otherness is relatively easy to control, and punters take up their place within the playful crowd, partly produced by and productive of the fairground atmosphere. With this in mind, it is interesting to consider Sir Robert Southwell's

advice to his son (in a letter cited in Henry Morley's *Memoirs of Bartholomew Fair* (1859, 288)), with instructions to 'g[e]t up to some high window to survey the whole pit at once.' Stallybrass and White add a gloss on this letter, noting how 'The father then goes on with his paternal guidance to provide a kind of conceptual grid through which his son should view and make sense of the fair. Edward [the son] should note the rope-dancers, the fools, the drunkards, the madmen, the monsters, the pick-pockets' and so on (Stallybrass and White 1986, 118). In this context, the spectator's elevation breaks the horizon(tality) of the experience, and bursts the illusion. In Edward Southwell's case, the advised vantage from a hotel bedroom would provide him not only with a clarity of understanding unavailable to those within the fairground but also a view of the behind-the-scenes of the various devices generating the illusion.

It is of course not uncommon to encounter the ruling classes remaining apart from, or above, the hoi polloi, physically or metaphorically. Much of the writing (and worrying) about the crowd that emerged from the late nineteenth century onwards generally 'viewed' it as a potential threat to good order, and direct physical contact with crowds as something for the ruling classes to avoid. Visual enjoyment such as that countenanced by Sir Robert Southwell was permitted from a safe distance. An interesting echo of these politics of crowd control can be heard in Peter Sloterdijk's consideration of the role of enclosing (hemi)spheres, 'visible and invisible ones alike,' in the project of European terrestrial globalization. Similar if only in the projection of enclosure undertaken by the fairground boundary surface, those within were held, overwhelmed, by their lack of a perceptual dimension afforded to those in the know. 'Wherever [European settlers] appeared, they usually proved the better observers: an observer is someone who perceives the other through a window of theory while themselves eluding counter-observation. As they had portable mental windows at their disposal, the managing Europeans were usually ahead of the discovered others by an entire dimension of description' (Sloterdijk 2013, 121–2).[9] Without suggesting that Bostock and his heirs should be likened to the European settlers in the New World, the showmen usually remain an entire dimension ahead of the punters in the fair. Those like Southwell, peeping over the fair-line boundary through a physical and conceptual window outside, gain an advantage that is generally unavailable—and with the playful crowd, willingly relinquished on entry—to those inside. Ruskin would be in the hotel with Southwell.[10]

The general availability of similar views behind-the-scenes does little to counter the power of the effecting of spatial enclosure produced by the composite fair-line boundary. Ann Brigham has argued that the increasing interest in and availability of organized and orchestrated behind-the-scenes tours is symptomatic of an 'increasing void in real experiences' available in everyday life: 'Forays into back regions, as staged as they might be, promised to show visitors the *real* ways people lived or things worked' (Brigham 2007, 209). The ordinariness (staged or not) visible to the fair-going crowd (or hotel-based voyeur) outwith the fairground does not undermine the experience within. In contrast to the carefully controlled transitional corridor through which visitors to the panorama would have to pass, controlling their decompression from the everyday world outside into the controlled spectacle within, the ambiguity of the location of the fairground's threshold plays on the encounter with the behind-the-scenes. Showing visitors the way things work on the fairground, or more specifically on the fair-line where the transition between an everyday world and a vast fairground interior, can heighten the sense of difference between these two types of space and the sense of enclosure within. Conversely, from within the fairground, punters do get to see 'behind-the-scenes' in another sense, a view back onto familiar surroundings made unfamiliar by the presence of the fair. Often, this outside can creep in without disrupting the experience, as the good-frontage surface is able comfortably to appropriate various incursions or intruders into its own surface effects, including adjacent buildings and street furniture, and more distant objects, buildings or landmarks.

Within the vast interior of the fairground itself, the behind-the-scenes operate in two further senses. Partly, this includes the 'interior' spaces of the rides and attractions where these operate as pockets of space accessed from, yet hidden behind and controlled by, the good frontage in front. Another behind-the-scenes, different in kind, are the areas within the fair where the public shouldn't go. This particular prohibition operates variously with health-and-safety exclusions keeping the public away from fast-moving machinery, with socially determined taboos allowing a degree of privacy around showpeople's living quarters if these are incorporated within the fair-line boundary, with operational areas clearly set aside for the showmen such as 'swag alley,'[11] and more or less physically inaccessible spaces between rides where stuff is stored, transport is parked, power generated or that simply left-over.

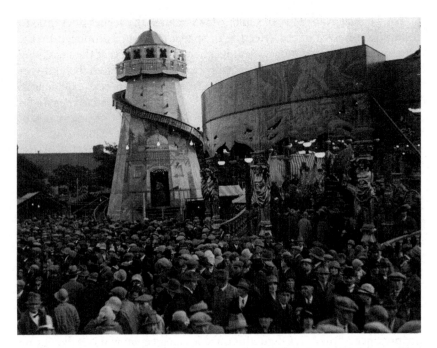

Fig. 6.2 Anderton and Rowland's new *Scenic*, and Whitelegg's *Lighthouse Slip*, Penzance Fair, 1921 (David Braithwaite Collection from the William Keating Collection. Reproduced with permission from the University of Sheffield Library, National Fairground and Circus Archive)

Within the interior of the fairground, there are more significant moments when the spectacle of the whole is temporarily suspended, if not broken. Similar to Southwell's advice to get up high, rides such as the Helter Skelter (or Slip) and the Big Wheel (or Ferris Wheel) offer punters an opportunity to physically rise above the horizontality that induces the illusion of enclosure and separation. Although both these examples offer paying customers the opportunity of an overview, this is in part a by-product of other temptations of the experience. On the Helter Skelter such as the one shown in Fig. 6.2, the overview is static and comes, and can be prolonged depending on the presence of other riders and the patience of the showmen, before the spiralling ride back down to earth is taken.

The Ferris Wheel offers a similarly elevated view; however, in contrast to the Helter Skelter, this is the selling point of the attraction rather than

a by-product, and combines the experience of motion and surveying that the Helter Skelter necessarily held apart. Moreover, it offers two modalities of viewing, as Mark Dorrian has noted (Dorrian [2004] 2015. See also Dorrian and Pousin 2013). Discussing the spectatorial experience available on the Ferris Wheel at its introduction as part of the World's Columbian Exposition in Chicago (1893), Dorrian draws our attention to a certain bivalence of vision available on the Ferris Wheel. In one direction, it offered an unobstructed panorama out towards the distant horizon; in the other, vision was interrupted by the structure of the ride, chopping this up into constantly changing fragments. One modality offers a slow-down experience (a bit like advice to the seasick, to look at the distant horizon), while the other emphasizes the speeding-up of mechanized vision, moving images anticipating the advent of film. Dorrian also draws attention to a bivalence that occurs between a quasi-ethnographic survey of the world that was offered by the various 'living villages' arranged along the 'Street of All Nations' situated within the Midway Plaisance along with the Ferris Wheel, and a feature of many world's fairs or expos before and since, and the simultaneous view of the future offered in the architecture of White City. While clearly this is not repeated in the fairground, there is something of an echo of this future/past bivalence in the tradition and novelty on offer on most fairgrounds. Figure 6.3 shows one example of this combination, where traditional and technologically modern options for gaining the elevated view are seen together at the northern end of Oxford St. Giles' Fair, 2012.

Although the opportunity for these kinds of overview, whether mobile or static, was and remains available for visitors both to the world's fairs or expos and to the fair, their role in these two settings is significantly different. As already noted, the intention of the world's fairs was productive, industrious and serious (however quickly this flipped into 'consumption and instant pleasure'), and within this didactic setting, elevated views were incorporated in sympathy with the broader desire to promote comprehension and orientation, both of the multifarious displays on offer and of the layout of the expo site itself. As Geppert notes concerning the Eiffel Tower at the Paris Exposition of 1889, the Flip-Flap at the Franco-British Exhibition in White City, London, in 1908, and various other unrealized proposals for other expos, 'These techniques for overview were as crucial for the exposition site's internal functioning as they were for providing an otherwise lacking central perspective ... masses of visitors reproduced these pre-structured movements' (Geppert 2010, 246). In contrast to the

Fig. 6.3 Oxford St. Giles' Fair, general view with a *Helter Skelter* in the background, and *'Storm' Mach 2* in the middle distance, 2012 (Photograph, Stephen Walker)

intended promotion of clarity and way-finding on the expo sites, and their explicit physical and metaphorical connection to the world beyond, techniques of overview within the fairground interrupt the logic of the surface-boundary and the interiority it attempts to establish. Their inclusion can be grasped more directly in terms of the novelty of the experience and the spectacle they offered.

More recent fairground rides and attractions have continued to offer a certain overview, although these arguably reinforce the work previously done horizontally by the good frontages along the fair-line. For punters on the ground, the vertical extent of the fair's delimited interior space is revealed more clearly, pointed out by frequent and multiple excursions into the air above, rather than simply implied by the horizontal bounding surface. For those taking these newer rides, the opportunities for a 'clear' overview really vary, as moments of physical removal from the horizon of

the fairground are often taken at high speed and on complex trajectories. For example, 'Freak Out' riders are taken over 20 meters into the air and Mach-2 riders over 40 meters, and they experience an acceleration force of around 3.5 G. (Fig. 6.3). Reverse bungee catapult rides reach similar heights, but at speeds of over 60 mph and forces of over 4.8 G. De Cauter refers to these generically as 'vertigo machines,' capturing the limited opportunity they provide for balanced and contemplative overview. 'Vertigo machines,' he writes, 'in all their different guises, led to one thing: the disappearance of the horizon' (1993, 21).[12]

For those with their feet firmly on the ground, this vertiginous experience has recently begun to be mediated, shown in real-time (and, when there's no action to screen, as replays) on large screens that form part of the base or frontage for these vertigo machines. The speed-up experienced by punters on these big ticket rides might prevent them from gaining an overview despite their altitude, but their experience of disorientation is now relayed, and enjoyed vicariously, by waiting punters and other members of the playful crowd. This approaches what Giuliana Bruno (2014) discusses more generally as an extension of the dynamics and tensions of contemporary spectatorship situated between absorption and dislocation.[13]

Although this chimes with both Ruskin's worries and Crary's more even-handed account of the changing modalities of perception discussed in the previous chapter (around the *trompe-l'œil* and the split self, respectively), there is something in the fair-line that arguably maintains the horizon. Vertigo machines might locally upset this (and in other ways, so too did Victorian and Edwardian attractions positioned on the fair-line), but the panoramic quasi-survey remains available, even if its limits are beyond coherent visual perception. Rather than giving itself up for capture or consumption like the (admittedly overwhelming) passive subjects of panoramic depiction, the individual and collective operation of good frontages along the fair-line resisted panoramic capture. This is not simply because their heterogeneous composition immediately disrupted any attempts at instigating a totalizing spatial experience, but because of the operational logic of the boundary so assembled.

For Andrew Benjamin, the products of this logic—surface effects— generally mean we do not need to perceive or grasp an overall form to understand a particular instance: every bit, every section, can animate and produce effect. More radically, this means that surfaces can be taken to have only one side and can be 'defined in terms of potentiality rather than simple literal presence' (Benjamin 2006, 4). Furthermore, as noted at the

beginning of this chapter, for Benjamin the interior surface *becomes a locus of plural possibilities*. Taken together, these two surface considerations help to account for the logic in play along the fair-line. In Benjamin's examples, a single hand executes the designs for surfaces. Even when considering Borromini's work on San Carlo alle Quattro Fontane, which arguably involved a certain collaging of architectural elements with different histories and from different periods, what is important for Benjamin is that these were composed within a system or logic that is fully integrative.[14] The composite, or collaged, surface of good frontages along the fair-line forms a surface-boundary with a slightly different logic of illusion, discussed in detail in Chap. 5, which in this context can be extended to emphasize its operation as both an interior surface and *locus of plural possibilities*. Whereas the panorama needs must operate by excluding reality and recreating the coherent and continuous illusion of a boundless space, the operational logic of the good frontage is as a surface with only one side, and the logic of the whole fairground is as an interior without exterior, akin to a cave. When Benjamin discusses illusion (via Borromini), this is a spatial illusion, not a *trompe-l'œil*. Nevertheless, the flexibility of his analysis is to discuss materiality in terms of its effect rather than limiting it to a physical surface, and his emphasis is on the generative logic developed by the artist or architect and its actualization in a piece of work: 'materials are what they bring about, what they effect' (Benjamin 2006, 22).

Sharing a pronounced anti-Cartesian starting point, Stroll's work engages less with the generative logic that informs the design of surfaces, and more with the ways in which people encounter or explain them: despite their pronounced differences in approach, Stroll can be understood to amplify rather than contradict Benjamin's reading of Semper in particular and architectural surfaces in general. At this particular scale, Stroll emphasizes the importance of the mobile spectator:

> Ambulatory vision occurs when a person is walking through an ecological ambience while turning his or her head from time to time to scan it. One who is walking and scanning is not apprehending a flat visual field, composed of connected snapshots, but a flow … As one moves and scans, the surfaces of objects emerge and recede; their textures absorb and reflect light; and as one moves, one is also aware of oneself. (Stroll 1992, 202)[15]

This difference echoes some of those rehearsed already, particularly concerning the difference in kind between the horizons related to the panorama and those bounding the fairground.

Stroll's interest is in the issues that emerge when we consider the differences between seeing the surface with and without seeing the object. As part of this analysis, he emphasizes seeing as a process that brings very different knowledge compared to wiping, touching and so on.[16] Pressing the point, he introduces an important distinction between magnification (which enlarges what can be seen by the naked eye) and resolution (which can introduce visual information of a different kind):

> But how much resolution gives us only the surface? ... is it plausible to suggest that if we reach a point of zero resolution, the only thing we could be seeing would be the surface of the object we are looking at? If this analysis is correct, we should look for some cases where the resolving power of the naked eye is either zero or virtually zero; and those might be cases where we could be said to be seeing only the surface of X, but not X itself. In the limiting case we would be apprehending only the surface and without any detail. (Stroll 1988, 84–5)

In the particular situation of the panorama, with its controlled viewing position and conditions, the magnification and resolution are held so as to remain subordinate to this overall illusory experience, preventing the (willing) spectator from fully isolating the surface of the illusion from the illusory object of perception itself. Transferring this consideration of the panorama *sensu stricto*, and the arguably false resolution/magnification that is on offer there, to the more metaphoric horizon provided by the frontages along the fair-line, we might ask if we can see the surface of the fair (its surface-boundary, its horizon) without seeing the fair (or even, if we can see part of the fair's surface without seeing the fair). Without resorting to Sir Robert Southwell's hotel window, the response as punters would be that we partly see or perceive it, but there is no 'fair-object' per se. As punters, we can only be inside looking at the separating limit between the fair and an outside. Teyssot generalizes this condition, noting that 'As with panoramas, theatres, panopticons and arcades, "what finds itself in the windowless house is what is true"' (Teyssot 2008, 10, citing Benjamin (1982, konvolut Q2,8, 660)). Although the resolution and magnification of the bounding surface along the fair-line might be such that we can never see the object it bounds, so long as its effects prevail there is arguably no exterior to the space of the fair. 'The true has no windows. The true never looks out at the universe' (Benjamin 1982, konvolut Q2,8, 660, cited in Teyssot 2008, 10). 'The interior, in this sense, had become a reversible surface, "like a sock"' (Teyssot 2008, 10, referring to Deleuze and Guattari (1987, 30)).

NOTES

1. In this passage, Benjamin is referring to the work of Adolf Loos, and the *Haus Müller* (Prague 1930) in particular.
2. Citing Walter Benjamin (1982, konvolut Li, 3, 511). Available in English as *The Arcades Project* (2002).
3. See also the inventories included in Geppert (2010), and particularly his account of White City, 'London 1908: Imre Kiralfy and the Franco-British Exhibition' (2010, 101–33). See also Greenhalgh (2011).
4. For clarity, this use of 'smooth space' is not explicitly related to a Deleuzian smooth/striated terminology.
5. Crary also emphasizes the individual, coherent and unifying nature of the panoramic experience, which 'in the context of urbanization, was increasingly incoherent. The viewing platform in the center of the panorama rotunda seemed to provide a point from which an individual spectator could overcome the partiality and fragmentation that constituted quotidian perceptual experience' (Crary 2002, 21). This shift from high-art to mass entertainment echoes those of the fair and the world's fairs noted above. See also Oettermann (1997, 8–12). In a further parallel between panoramas and fairground rides, Wilcox describes how panoramas toured until they were worn out, or were overpainted if they were no longer of sufficient interest to attract audiences (Wilcox 1988,16).
 As usual, this art historical dispute concerns the primacy of painting. Hernández Barbosa notes how 'The symbolic function of the panorama, which was supported by the capturing of the horizon, has been challenged by Grau, who points out that the representation of the horizon was a quest begun by art centuries earlier, and which cannot, therefore, be associated specifically with this artistic format' (1999, 143–4). Robert Barker, who patented the panorama on 19 June 1787, promoted himself, and his invention, as an 'IMPROVEMENT ON PAINTING' (Barker 1787, cited by Wilcox 1988, 21). Reliably, and much like his attitude to the *trompe-l'œil* discussed in the previous chapter, Ruskin damned the panorama with faint praise, recalling the 'admirable presentment' of a view of Monte Rosa in Burford's panorama in Leicester Square, in contrast to his dismissal of Calame and another painter (whose name escapes Ruskin), as 'merely vulgar and stupid panorama painters' (Ruskin [1885–89] 1908, 117), and a letter to Mr. Freshfield (Ruskin [1878] 1908, 567).
6. See also Crary (2002, 19).
7. Robert Weedle has discussed the various ways in which modern technological means have been used to 'amplify' the baroque traditions of all-encompassing nocturnal spectacle (plays of water, light, fireworks, music and speech) in recent world's fairs and expositions, particularly the Parisian International Exposition of 1937 (Weedle 2008, 215–37).

8. As mentioned in the previous chapter, any comparison of the fairground with theatre is best undertaken in the spirit of Ford's work on spectatorial ambiguity, akin to Aristotelian political theatre. The emergence of the proscenium arch, seated stalls (replacing the mosh-pit) and the darkening of the auditorium in the nineteenth century, all echoed or accompanied the gradual privatization of the theatre experience. As Louise Pelletier notes, during the late eighteenth century there remained some ambiguity between these two positions, some possibility for the audience to become involved in the action, to become actors themselves. See Pelletier (2006), particularly Chap. 5, 'Theatre Architecture and the Role of the Proscenium arch.'

9. This comes from a chapter on 'The Five Canopies of Globalization: Aspects of European Space Exportation.' In developing his analysis of these Five Canopies, Sloterdijk's examples reinforce the surface-effecting power of canvas that is at play throughout my account of the good frontage, when he emphasizes 'the precedence of the ritual framework over the physical building' and notes the 'tent roofs of the traditions and ritual safeguards' of the European settlers (and here particularly, the Founding Fathers) (2013, 127).

10. See also Reinhold Martin's discussion of the difference between a Deleuzian and a Leibnizian schema that 'includes a vertical relation that materially orchestrates an imagined transcendence—that is, it produces a window-effect within the windowless monad—while the one based on Semperian gates that convert nomads into herders remains bound to the earthly plane' (2016, 108).

11. Swag Alley is effectively an area of the fair off-limits to the public, a wholesale market where showmen can buy topical prizes (or 'swag') to offer punters.

12. The broader trajectory of De Cauter's essay traces 'the implosion of the panoramic gaze as the modern form of representation' (1993, 20). Anticipating Crary's longer study of the fragmentation of the whole subject within the onset of accelerating technological development and modernization during the nineteenth century, De Cauter also enlists new, ever-faster modes of transportation—the bicycle, the train and the automobile—in his diagnosis of the failure and disappearance of a coherent representational system exemplified by the panoramic gaze, and the formation of a new eye/spectacle ushered in with the new medium of film. 'The panoramic ecstasy had to make way for the transport caused by transportation: the pleasure of speed. This acceleration (of transport, but also of information) unchained the collapse of a whole system of representation' (1993, 16–17).

13. See also Huhtamo (2012).

14. In 'Plans to Matter' (2008), Benjamin goes on to emphasize the difference between this integrative Baroque system and the fragmentary logic of the neoclassical approaches that followed.

15. This passage, as with much of his work, develops a conversation with Gibson's ecology (the triad of medium, substances and surfaces). See in particular Gibson (1979).

16. While epistemological challenges emerge from this, it also highlights the socio-culturally conditioned contexts within which touching, wiping and so on are acceptable: not, for example, at the museum or the theatre, even if the latter is Böhme's paradigmatic example of atmosphere generation. Elsewhere, Böhme sets out an account of atmosphere that enjoys more of an ambiguity, bivalence even, of the thing as both an enclosed form-object and as something that radiates an external effect. From this conception, Böhme argues, 'it is possible to conceive atmospheres in a meaningful way. They are spaces insofar as they are "tinctured" through the presence of things, of persons or environmental constellations, that is, through their ecstasies... atmospheres are thus conceived not as free floating but on the contrary as something that proceeds from and is created by things, persons or their constellations' (Böhme 1993, 121–2).

CHAPTER 7

Surface and Effect: Architecture and the Patterning of Experience

Abstract Borrowing and reframing a chapter title from Douglas Spencer's recent book on *The Architecture of Neo-liberalism*, this final chapter synthesizes some of the main issues that have run through the book (showfront, boundary, crowd and atmosphere) and draws out broader connections to contemporary debates concerning the architectural surface. It returns to the philosophical work of Andrew Benjamin and Avrum Stroll, and discusses in particular Stroll's conceptual 'point of zero resolution,' where an observer can apprehend only surface. It argues that in front of the 'good frontage,' there is always interference, even though Bostock's good frontage set out to provide a single surface effect that could harness the full attention of a fair-going crowd.

Keywords Avrum Stroll • A-Surfaces and P-Surfaces • Direct and indirect perception • Architecture of affect

Borrowing and reframing a chapter title from Douglas Spencer's recent book on *The Architecture of Neo-liberalism*, this final chapter synthesizes some of the main issues that have run through the book and draws out broader connections to contemporary debates concerning the architectural surface. The fair-line—how this is conceived, what it organizes, how the material and decorative good frontages arrayed along it develop over time, and the impact it has on punters—has been discussed in earlier chapters as

a surface, as a surface-boundary and as a surface-boundary-limit: these apparently pedantic distinctions came from Stroll's forensic scrutiny of what he refers to as the 'Geometry of Ordinary Speech' (See in particular Stroll 1988, 199–203). Taking the 'ordinary person's' commonsense response to surface perception and understanding, Stroll combines this with contributions from artists, philosophers and scientists, observing the conceptual differences these contributions offer, particularly around questions of whether surface is held to be a physical boundary property of a thing, or a conceptual limit between things. Stroll goes on to argue that it is not possible to arrive at 'some conception of surface, regarded as a boundary, that encompasses both [abstract surfaces (which he refers to widely as A-Surfaces) and physical surfaces (P-Surfaces)]' (Stroll 1988, 64).[1] Moreover, it is possible for either of these, abstract and physical surfaces, to be applied to the same surface, but not simultaneously: these are 'distinct conceptions which are subtly interrelated' (Stroll 1988, 64). It is interesting to note that architect and theorist Bernard Cache has acknowledged how he was 'attracted to the philosopher Avrum Stroll's book *Surfaces* because it offers the possibility of seeing surface both as a physical entity and an abstraction, and makes no claims about the primacy of one surface above another. It is a discussion that is played out on many levels' (Cache 2003, 31).[2] While Stroll's philosophical discussion explores these many levels while retaining the fundamental ambiguity that surfaces present, a similar ambiguity can be encountered both by punters when bounded by the good frontage of the fair, and in considerations of the latter's operation.

Whereas Andrew Benjamin's work is more focused on what happens in the process of conceiving and actualizing the surface, Stoll is happy to take this as a given and to scrutinize how such a surface effects an observer's understanding of it in various ways, and how that observer's particular relation to and mode of viewing the surface, how they ask questions of it, have a significant role in how it is understood. Acknowledging the complexity this brings, Stroll asserts: 'contextual factors play complicating and perhaps even determinative roles' (1988, 85). For all his critical acuity, Benjamin's examples do not press him to take up the contextual experience of or complex encounter with the (architectural) space that surfaces effect. His careful reading of Semper, and his close readings of the actualized works of Bernini and Loos, signal raw material for architects to consider and question. Admittedly, the contextual conditions for engaging with the fair-line are not those shared by a visitor to San Carlo alle Quattro Fontane (nor indeed to Loos' Haus Müller). Benjamin's work was clearly

not addressed to events that are as crowded or complex and messy as the fairground, the spectatorial conditions encountered there and the interior-exterior ambiguity discussed in the previous chapter.[3] Nevertheless, I want to suggest here that it can be extended when brought into contact with this particular situation. Stroll's acceptance of contextual factors is central to much of his work—'This is real life, not laboratory, seeing', he claims in *Reflections* (1992, 201)—although his real-life settings do not include many crowded environments. Despite this proviso, Stroll's acknowledgement that 'atmospheric effects ... play important roles in the perception of surfaces' (1992, 200) can be expanded beyond his examples of the role played by moisture and dust on the clarity of an optical environment within which surface perception takes place. Other atmospherics can also have an impact on this clarity, particularly when the perceiver is part of a crowded fairground: smells, noise and music, physical bodily proximity, and the complexities of individual and collective memories. Moreover, Stroll's examples of motion include moving objects, such as a spinning top, and the blurred surface patternation produced by its motion: it is not a difficult leap from this example of ambiguous surface perception to that produced by the moving surfaces of a fairground ride.

Stroll is emboldened to valorize ambiguity, rather than try to overcome it: he is critical of a common separation he observes between direct and indirect perception, which are frequently linked to different modes of perception or attention, and the lack of provision in most theories for these to be available in the same experience. Indirect perception is usually associated with perception inflected via media, he laments, rather than with our own perception in a specific atmosphere, environment and movement. Writing in 'Reflections,' Stroll's conclusion, and arguably the conclusion to his entire œuvre, is that no first-order theory of surfaces is possible (Stroll 1992, 210). In other words, neither the materiality of a surface nor the conceptual and perceptual responses it involves can ever be isolated or silenced enough to allow a once-and-for-all account to be given. Demanding a broad reading of scales, viewing positions and mobile spectatorship, of 'magnification' and 'resolution' introduced at the end of Chap. 6, this returns us to the crowd-based spectator, as much as the intentionality of the surface-author, and the potential ambiguity or doubling they experience at the fair and as a result of the fair-line. This spectator's encounter with the fairground surface involves a direct (on Stroll's account, an engagement not 'mediated' by instruments, although at the fair this viewing experience may involve various modalities of illusion,

discussed at length in Chap. 5) as well as indirect engagement (this occurs in a distracted mode, caused by a wide range of stimuli external and internal to the spectator). Within these complex factors productive of the fairground's surface effects, it is particularly interesting to consider whether it is possible to reach a *point of zero resolution*, such that within the complex ambiguity of this experience, it is only the surface, the good frontage, that we see. While Stroll links this consideration to the 'resolving power of the naked eye,' the surface arrangement of the good frontage and the contextual factors or atmospheric effects must also be granted a role in the ambiguity that resists resolution.

With different concerns, both Stroll and Benjamin account for surface effects in terms that balance both A- and P-Surfaces, to stick with Stroll's terminology. This is not a fudge, but a strong and reasoned denial of neither one dominating or gaining priority, of establishing a first-order theory. Broadening this discussion, the ambiguity central to the operative function of fairground surface effects and the business case behind Bostock's mantra find unexpected echoes in a more recent resurgence of interest in the architectural surface, particularly what Douglas Spencer (2016) refers to as an 'architecture of affect' associated with complex digital design and fabrication processes. In certain ways, this interest could be taken to pursue the *point of zero resolution*, a 'limiting case [where] we would be apprehending only the surface and without any detail' (Stroll 1988, 85). What for Stroll was a philosophical speculation returns here as an architectural attempt at absorption, at the production of a surface whose effect is entirely predicated on affective understanding that operates at a precognitive level. The latter does not deny effect, quite the opposite, but its absorption-effects are by comparison context-free and communication-free and need to be considered carefully. At the fair, immersion or absorption in surface effects is far more contingent, playful and performative. It is as immersive as a punter is willing to accept, because external 'reality' offers to press through almost everywhere. The good frontages are all about communication (albeit a complex communication that also involves illusion and a degree of scrambling of this information that potentially spills into the fairground from outside), and are supplemented by barkers and spielers who set out, in combination with the showfront, to attract and hold a crowd, and persuade members of that crowd to become paying customers.[4]

In his considerations of contemporary architectural practice, and contemporary surface practice in particular, Gevork Hartoonian's concern is

to link the current (over-)interest in surface as image into a longer histori-
cal trajectory. Important in the present context are two of his introductory
questions, namely, 'How architecture thrives through the production and
consumption systems of capitalism,' and how the contemporary role of the
image in architecture has become 'valorised beyond what was experienced
through the spectacle of old carnivals and stage-sets, one main task of
which was to dramatize the event and/or the play respectively' (Hartoonian
2012, 1).[5] Acknowledging that much contemporary digital- or paramet-
ric-design-generated surface architecture must be criticized, Hartoonian
admits that it raises important questions for architectural theory's consid-
eration of surface and links this to 'the overwhelming presence of the
image in contemporary culture, which has been intensified by the recent
turn to digital technique' (2012, 1). He is agnostic about the role of the
image, although is keen to promote an architectural surface that develops
beyond those of the simple carnival spectacle. How much his chosen
examples succeed is a moot point, but it is clear that the intended reach of
these new surfaces is expected to operate within a different mode: in con-
trast to the old carnivals and stage sets, which were to advertise or frame
the spectacle contained within (à *la* Bostock), new surfaces mobilized by
an 'architecture of affect' operate to hold the spectator's attention within
their own depth. Whereas the old stage sets were criticized by architects
for being insubstantial, for prioritizing superficiality over structural or tec-
tonic integrity, new surfaces make a spectacle of their own tectonics.

In an essay entitled 'Staged Materiality' and first published in 1995,
Gernot Böhme traces a similar change in the conception and presentation
of common material elements of architecture, shifting from a concern
with materials in themselves towards the characteristic appearance of these
same materials. He goes on: 'Decades ago, Jean Baudrillard spoke of the
valeurs d'ambience. Nowadays this phrase should probably be translated as
"theatrical value"' ([1995] 2013a, 95). Since Böhme wrote these words,
the situation with the new architectural surface has only intensified: it is
not so much the ambience or atmosphere that this surface is charged with
effecting, but (paradoxically) a new staging of the surface material itself.
Indeed in more recent work, Böhme has discussed how 'The manipulation
of objects serves only to establish conditions in which these [scenographic]
phenomena emerge' (2013b, 4).[6] The site and dynamics of this scenogra-
phy shift away from the broader atmosphere and onto, or into, the surface
itself and its object manipulation. The illusions that can be located here are
'contrived to appear as immanent to matter, the patterning, an emergent

property of its operative capacities. Any allusions to anything beyond material immediacy, any representational figures, are eschewed, as if in obedience to some prohibition on graven images' (Spencer 2016, 159).

In other words, in this recent context, the relationship between spectator and surface object or surface matter and image is prioritized, at least in design intention, over previous concerns with the generation of ambience or atmosphere. Böhme reasserts the importance of studying the concept of atmosphere from both of these positions, the object or surface itself and the subject's encounter with it. While he repeats his frequent assertion that the stage set serves as the paradigm for this approach, he both extends and qualifies the application of the particular relationship this sets up between subject and object in urban contexts. There (and by extension in the fairground) particularly,

> This paradigm falls short of the mark … [since] atmosphere is … produced for the actors themselves, as it were … In fact, the paradigm of the stage set actually entails dangers for architecture … These dangers consist of something akin to the aestheticization of politics criticized in his time by Walter Benjamin: to grant the masses "not their right, but instead a chance to express themselves." (Böhme [2008] 2017, 79 citing Benjamin [1936] 1973, 234)

Without conflating it with the operations of fascism that Benjamin was addressing directly here, I want to reintroduce Hartoonian's first question concerning architecture's long-term liaison with 'the production and consumption systems of capitalism' in order to situate the surface operations of the 'architecture of affect' within an expanded historical trajectory. Contemporaneous with the growth of fascism in Europe, the white-walled modern architecture that Mark Wigley analyses displays certain parallels with the surface operations espoused by the 'architecture of affect' in terms of what Wigley refers to as disavowal. As discussed in Chap. 4, despite the evident difference in their 'architectural' arrangement, white-walled modernism and the good frontage at the fairground can both be taken to disavow their structure. This distinction is easier to identify in material terms along the fair-line, but whether this is taken as the repressed, excessive other of the neutral white façade, or simply a contemporary counter-example, both involve a sleight of hand, a double bluff, that manipulates or tricks the observer or the punter by distracting them from the broader machinations of these architectures. Wigley describes this as the self-subordination of a surface, albeit one that operates with the express intention of concentrating all its energies on making the outer

layer available to the observer. 'But this subordination is itself only ever a surface effect. It is the self-subordination of a surface that is more controlling than controlled. Modern architecture is never more than a surface effect' (Wigley 1995, 122–3). The corollary of this self-subordination was a machinic understanding of the viewer reduced to what Gropius likened to a 'camera passing through the building.' In its own way, the fairground (and the theatre) is a highly aestheticized or mediated environment, where the dynamics of disavowal differ but the agency of the punter is similarly reduced and subordinated, as they become caught up in complex relational interactions produced by and productive of atmospheric effects that Böhme would relate to the 'ecstasies of things.'

In both these cases, the disavowal operates within a broader and messier context of 'ecstatic things' than the delimited surfaces themselves. The surfaces concerned attempt to wrest control over these broader contexts, and the subjects therein, through the operation of their effects. With the recent 'architecture of affect,' in contrast, the dynamics and direction of this relationship change, and the disavowal can be understood instead as a denial of any interaction beyond the material immediacy of the surface itself. Some of the backstory to this situation is revealed by Böhme, as he wrestles with the limitation of his own interest in the stage set as a model for understanding, and potentially designing, urban atmospheres. Arguing against reductive semiotic readings of architectural postmodernism in various guides, both structural and superficial or decorative, Böhme suggests that these binary distinctions 'fail to recognize that the era of representation has long since passed' (Böhme [2008] 2017, 77, referring to Redner [1994]).[7] Böhme's push is both historical and theoretical: to acknowledge that many of the world's cities have changed significantly beyond those that were occupied by, and that occupied, modernist and postmodernist architects and theorists. While the prevalence of the superficial image has continued to grow, the complex cultural constituencies of many cities precipitate the emergence of images that can address multiple frames of reference rather than assuming a generally shared symbolism. 'And that means' Böhme adds, 'that what appeals to us in a city cannot be interpreted as a language but enters our disposition in the form of impressions' ([2008] 2017, 77). Böhme's own vacillation finds echoes in the situation he tries to describe here, which can be understood in terms of an increasingly complex context within which architectural and other languages effect meaningful atmosphere, or of an environment within which interest in meaning is replaced by impressionistic enjoyment.

Perhaps the best-known architectural examples that crop up in in these kinds of discussions are the Las Vegas Strip (already mentioned in Chap. 2) and the Bonaventura Hotel in Los Angeles (designed by John Portman, constructed between 1974 and 1976), which initially reached a critical audience thanks to the writings of Robert Venturi, Denise Scott Brown and Steven Izenour and of Frederic Jameson, respectively. I am mindful of a certain Vegas and a Bonaventura fatigue within architectural writing, but there are some points of contact that remain sufficiently relevant for the present discussion to warrant the reintroduction of these examples here. Jameson sets out how the exposition in his book 'will take up in turn the following constitutive features of the postmodern: a new depthlessness, which finds its prolongation both in contemporary "theory" and in a whole new culture of the image or the simulacrum' (1991, 6). He links the Bonaventura Hotel in to this broader exposition because he believes it 'offers some very striking lessons about the originality of postmodernist space' (1991, 39). Moreover, he suggests that it signals a significant change in architectural attitudes towards the modern vernacular: this new architecture 'no longer attempt[s] ... to insert a different, a distinct, an elevated, a new Utopian language into the tawdry and commercial sign system of the surrounding city, but rather ... seek[s] to speak that very language, using its lexicon and syntax as that has been emblematically "learned from Las Vegas"' (1991, 39).

At face value, it seems Jameson is amongst many other critics to line up behind Denise Scott Brown and Robert Venturi's work and link their learning to contemporary architectural practice. Another writer in this habit is K. Michael Hays, who draws on Scott Brown, Venturi and others in order to link 'the Advanced Architecture of the Present to that of the 1970s.' Drawing on this work, Hays argues that

> The perception of architectural surfaces began to overtake the experience of urban space in the traditional sense. Image consumption began to replace object production, and the sheer heterogeneity of images exploded any single, stable typology of the city. Public meaning was now to be found in the signs and perceptual habits forged in a pluralist, consumerist, suburban culture (2001, 103).[8]

Although this echoes Böhme's vacillation regarding contemporary impressionistic public meaning, Hays goes on to argue more directly that the 'collaged semiotic surfaces of architecture' celebrated during the 1970s conform to new media superficies. What is more surprising perhaps is the

narrowly time-bound concern that Hays draws upon (as well as the narrow 'pedigree' of works he enlists from the 1970s). That 'Advanced Architecture' had long ignored the 'tawdry and commercial sign system,' and 'perceptual habits forged in a pluralist, consumerist, suburban culture' is old news, but to limit the recently discovered history of this other world to the 1970s is to overstate that decade's relevance, and overlook a wider range of work and longer lineage as a result. The architect David Braithwaite, for example, made a similar claim but directed at a much earlier moment, where fairground showbooths got themselves up in fancy frontages during the early nineteenth century, a technique which was passed on to displays in shops (Braithwaite 1976).[9] At mid-century, Le Corbusier expressed a more ambivalent response to the commercial sign system of 'modern times' (in terms that remind us of Bostock's mantra): 'Electricity reigns ... The things behind it are disappointing. These close-range constellations, this Milky Way in which you are carried along, lead to objects of enjoyment which are often mediocre. So much the worse for advertising! There remains a nocturnal festival characteristic of modern times' (Le Corbusier [1937] 1964, 102).[10] Recent histories of Las Vegas, if not exactly revisionist, draw attention to many earlier moments of surface manipulation in that city's development and also to practices of transfer from vernacular architecture into other contexts such as the film industry.[11] As Stefan Al notes, 'Ironically, the false fronts in the Hollywood movie sets were also typical of frontier towns. Historian Richard Erdoes later wrote of Western architecture: "The false fronts were pasted like sheets of cardboard to one-storey log cabins or board shacks to give the impression of splendid two-storey saloons"' (Al 2017, 23, citing Erdoes 1979, 37).

However, it is received wisdom that these exchanges (and falsifications) were apparently going on under architecture's radar until Izenour, Scott Brown and Venturi drew attention to them. To add a twist to this story, a recent study by Gabrielle Esperdy suggests that they were also going under the radar of the citizens who lived and worked in these suburbs, or on Main Street. One of her main points is that although the proto-strip architecture that *Learning from Las Vegas* goes on to study and celebrate in 1968 had been developing across the USA for decades, and had been photographed and published in *Time Life* magazine from the early 1950s, the general population did not seem to notice its impact or even register 'the problem': 'When *Life* reviewed *Learning From Las Vegas* in 1972, it was clear that the [largely white and middle class] social mainstream the magazine represented did not yet comprehend this new point of view' (Esperdy 2014, 188–9).[12] The awakening of the architectural profession—

of more particularly, those small bits of the profession involved in 'Advanced Architecture'—to this previously overlooked, pluralist visual environment and culture cannot easily be explained as a bow to populism, if the 'social mainstream' did not actually possess the 'perceptual habits' they were believed to hold. Redeploying the 'lexicon and syntax' of the commercial sign system might well have underwritten some of the developments of postmodern space that Jameson observes, but it also precipitated the impressionistic response to the cityscapes we are now left with, and that Böhme argues we are unable to read.

As already noted, Jameson associates postmodernism with a new depthlessness. Developing this claim through his well-known close reading of the Bonaventure Hotel raises a number of spatial, superficial and experiential similarities to the fairground, and particularly the effects of the good frontages that surface the fair-line. Jameson grasps the Bonaventura as total space, a complete world, deliberately cut off from its urban context by a reflective façade that provides a lack of any perceptible exterior. From the outside, it is also difficult to find the (multiple) entrances, and once inside, the effect is radically disorientating, despite its apparent clarity of the layout on plan, a feeling that is amplified by the spectacle and excitement of movement provided by escalators and elevators, by the deliberate distraction provided by hanging streamers, and that produces 'milling confusion' (Jameson 1991, 39–44). This is not to suggest that the Bonaventure can or should be conflated with a fairground; what is more relevant in the present context is the way in which this internal space somehow eludes Jameson's capacity for cognition or description: 'I am tempted to say that such space makes it impossible for us to use the language of volume or volumes any longer, since these are impossible to seize' (Jameson 1991, 43). Spencer glosses Jameson's disorientation and incapacity to read the Bonaventura by linking this to more general 'obstacles to critique caused by the loss of depth and distance, [and] the difficulties in even locating a position from which to reflect critically upon experience' (2016, 152). The surface effects of the Bonaventura are difficult to identify: while the external surface disavows both the overall form of the hotel and its relationship with its neighbourhood thanks to the operations of its 'great reflective glass skin' (Jameson 1991, 42),[13] the interior disorientation cannot be easily tied to the operation of internal surfaces. Nevertheless, the late- or post-modernist Bonaventura can be understood as a middle term between the disavowals associated with modernism's white wall and with the 'Advanced Architectural' surfaces

characteristic of the 'architectures of affect.' Allied to this lineage, the 'imperative to grow new organs, to expand our sensorium and our body to some new, yet unimaginable, perhaps ultimately impossible, dimensions' (Jameson 1991, 39) that Jameson sets out as a forlorn response to the disavowal of the Bonaventura Hotel has (as he foresaw) failed to come about. Lacking this renovated sensorium, we continue to struggle when faced with 'Advanced Architectural' surfaces, which fold these concerns into a critique-free 'enjoyment of immediacy' (Spencer 2016, 152).

Notwithstanding this failure, the operations of 'Advanced Architectural' surfaces can be compared with the good frontages along the fair-line in ways that distinguish the logics of each one, as well as identifying characteristics and tendencies that they share. Approaching this firstly at the larger scale of the fair-line understood as a panoramic bounding horizon as this was introduced in Chap. 6, these two surfaces can be taken as attempting to control their respective punters or spectators. Although the various elevated vantage points available offer to break the illusion of the fairground as a vast interior with no outside, the provision of these overviews within the fairground has become less contemplative. In contrast to Sir Robert Southwell's hotel window and the Ferris Wheel, more modern 'vertigo machines' provide elevation at such velocity (in the strict sense of speed and vectoral direction as well as orientation) that it remains difficult for the punter on these rides to attain a critical distance or context within which they can make sense of any information gained therefrom. In this sense, there is arguably a similarity between the quasi-panoramic horizon of the fairground and the 'smooth' experiences offered for immediate enjoyment by the 'architectures of affect.' Both can be taken to challenge the sensorium in related ways. Although the vertigo machines do not offer a bland smoothness, neither do they offer an overview with critical potential. Despite this frustration, they provide a reminder that there is an outside, and that the bounded, interior experience of the fair is produced by precisely this generating logic in the fair-line surfaces.

Phrasing this according to Stroll's A-Surfaces and P-Surfaces, separate accounts can be given of the perception of the fair as a bounded interior that are clearly reliant upon either of these, abstract or physical. A-Surfaces, associated with the generative logic that underwrites the operation of these good frontages as surface-boundaries, are to a large extent drowned out by the more immediate contribution made by P-Surfaces to the punter's perceptual experience of the fairground. A-Surfaces can nevertheless come to the fore, temporarily foregrounded in moments of elevated

vantage: whether these moments are sufficiently steady to undermine the enclosing intentions of the fair-line is not a major concern, as even their fleeting (even vicarious) experience is sufficient to satisfy Stroll's demand that no first-order theory of perception could be achieved for the fair-line. Within the fair, we're always caught somewhere between the subtly inter-related, distinct conceptions linked to A- and P-Surfaces.

Another sensorium failure occurs when the punter or spectator is physically closer to the good frontage or architectural surface, and is related in particular to discussions of ambiguity that were set out at length in Chap. 5. Introduced around the *trompe-l'œil*, these ambiguities in experience were linked to other instances, including Aristotelian spectacle (*opsis*) and the related concept of *katharsis* (operating between spiritual/intellectual and physical/material registers), as well as Crary's distinction between the attentive and inattentive observers. Described there as a boundary confusion that sets up and sustains two modes of looking within the observer (and which allows them to experience a certain delight in their own perceptual doubleness), in the present context this particular ambiguity can be re-read according to Stroll's terminology. The perceptual doubleness enjoyed as a result of *trompe-l'œil* and various other examples of surface illusion, including false or superficial materiality and visual trickery at various scales, operates by leading the viewer to grasp this experience as an oscillation between or progression from A-Surfaces to P-Surfaces (or vice versa), usually induced by the impossible co-presence of two different P-Surfaces.

For Stroll this is a philosophical distinction, but at the fair it is fun, and regarding 'Advanced Architectural' surfaces it arguably marks aspects of their logic to be both extended and avoided. More precisely, the latter operate by setting up a P-Surface with such internal complexity that its surface effects enjoy an ambiguity that is marked by absorption. The experiential consequence is to discourage spectators from switching their mode of perception in order to explore the A-Surface or logic of that surface spectacle. In temporal terms, this is marked as something of a refusal of an historical perspective, with a focus instead on the experiential. The former (with its offer of a critical overview) is avoided, while the latter (with its counter-offer of permanent absorption in the present) is extended. We could go so far as to suggest that there are two trompe, one associated with Bostock and the other with the lineage that runs from the white wall to the Bonaventura to the 'architectures of affect.' While these clearly appear different, it is important to explore whether they are different in kind, or simply in degree.

Proponents of the 'architectures of affect' such as Alejandro Zaera-Polo emphasize the particular logic that underwrites this experiential absorption: 'The present-day envelope, the primary depository of contemporary architectural expression, is now invested in the production of *affects*, an uncoded, prelinguistic form of identity that transcends the propositional logic of more traditional political rhetoric ... Envelope design has consequently focused on the construction of the surface itself' (Zaera-Polo 2008, 200).[14] While this can be taken as a counterclaim to Jameson's imperative, it also returns us here to Angela Carter's repeated celebration that the fun of the fair was simply and only bodily, entirely sensational and that it expressly did not concern the intellect (see Chap. 5). But the crucial difference between these positions is that, for Carter, there is very clearly an outside: we knowingly enter the fair and (on her account at least) enjoy it bodily, sensationally and quickly. Two further qualifications must be made here: Carter's œuvre is one of sustained critique, and she would be the last person to advocate generally for a brain-free, fun engagement with the world. Secondly, her advocacy of the fair as visceral and throwaway must be read as a counter-argument to those that only valorize the intellectual: it is not anti-intellectual. Taken in this broader context, her writings on the fairground offer some encouragement that once we decouple from the immediate enjoyment of the fair, we can take a broader view. We can stop, take stock and reassert our subjectivity.

At a more collective level, these two trompe can be associated with the respective surface-boundary response to the crowd or group. Recalling the riverine metaphors discussed in Chap. 2, which were particularly popular with Victorian and Edwardian writers in their fearful portrayal of the growing urban crowd, the mindless mass of humanity was described as being contained, bounded and directed by the good frontages along the fair-line. The anonymous reporter writing in *The World's Fair* in 1908 likened the crowd to 'some great river clotted with matter, twisting and turning between its two banks as best it could' (Anon 1908), without any plan or ability to govern itself. Considered from within, the two banks of this 'river' can be taken here to operate simply as P-Surfaces, capable of containing the masses in their irrational, swirling motion, presumably until they dispersed or leaked away, regaining their individuality and consciousness as they separated from the crowd. Considered from without, however, by those capable of a rational overview and the understanding that this brought, that is to say both the showmen and the ruling classes, the surface-boundary was an A-Surface, a conceptual plan that was implemented

as a physical containment. Although crowds of this size and associated threat do not perhaps rub up against the 'Advanced Architectural' surfaces in quite the same way, the latter's response at times draws on a surprisingly similar vocabulary, such that Peter Adey summarizes various theorists' work on the affectual encounter as being 'envisage[d like] an individual amidst a swirling and infinite sea of materials and bodies' (2008, 440)[15] and can be understood to be that of a single, super-absorbent P-Surface, able to diffuse the perceived threat of the individual or the crowd not by containment but by rendering them distracted.

In other words, the ambiguity generated by the fair-line and associated with fairground experience involves a temporary acquiescence to the trompe on offer. Critical reflection may be suspended, but the enjoyable ambiguity of the fair involves the interplay of both A-Surfaces and P-Surfaces. In his conclusion to the article cited earlier, K. Michael Hays similarly makes a suggestion for 'A new kind of reception ... in which the sensory, the aesthetic, is somehow mingled with the theoretical' (Hays 2001, 105). He outlines a 'triple duty' on the Advanced Architecture of the Present, related strongly to legibility and representation of the surface. In contrast, the second trompe, that associated with the 'architectures of affect,' involves a temporal acquiescence, or more strongly a disavowal, with the intention of suppressing any link to A-Surfaces or the critical capacity and distance these offer. That said, these two trompe are not necessarily different in kind, as arguably the 'Advanced Architectural' surfaces are approaching the logic and operation of the good frontage, while in the process expanding what was only ever a temporary condition towards a prolonged state of inattention, as a distraction or sustained pleasure invoked as a new norm.

A-Surfaces and P-Surfaces play out differently in the ambiguities of these two situations, and more obviously in the respective logics of their surface effects. The 'architecture of affect' pushes effects through the emphasis it places on P-Surfaces (particularly manifest in physical virtuosity, material ambiguity and patterning), putting A-Surfaces in abeyance (withholding their logic from the experience, or, more strongly, concealing the underlying logic of this purportedly 'uncoded, prelinguistic' architectural approach behind a declaimed interest in material and constructional exploration and its expression). Indeed, one of the consequences of this withholding is to push the material encounter with these surfaces into what was intended by Stroll to be a philosophical situation, namely, a point of zero resolution, where we only see the surface, and where that surface

is radically decontextualized. For Stroll, this occurred as a kind of limit case, where a particular balance between magnification and resolution provided a direct and totally absorbing experience of the surface, free from material depth and context. But even here, the point of zero resolution is one that is arrived at through a particular contextual to-ing and fro-ing that progressively excludes readings of material depth and context, not one into which we can arrive directly. Stroll's concluding argument continues to hold: this moment of zero resolution cannot fall entirely and exclusively into the domain of either A-Surfaces or P-Surfaces. Much as 'real-life seeing' might prevent this exclusivity, the 'architecture of affect' moves quickly in this direction and presents a generative logic predicated on the belief that it prevails.

This continued reduction of interest in the surface to the surface, increasingly as an end-in-itself and apparently divorced from other dynamics, material and socio-cultural, has certain echoes of Dorrian's criticism of Böhme concerning the naturalization of atmosphere. (Such that atmosphere seems to separate itself from, only to covertly return to, a subject-object relationship that repeats previous power structures, rather than to instigate new assertions of subjectivity that challenge the status quo.) The trompe of this trompe is to displace the locus of trickery away from the encounter with surface and onto or even into the surface itself. In contrast to the trompe of the good frontage, where the trick is revealed in the measure of that encounter against the subject's 'normal' expectations of the world around it, the trompe offered by the 'architecture of affect' refuses the subject's capacity for critical reflection beyond surface experience. In this sense, it repeats, or updates, a certain 'subordination' that Wigley observed in the surface architecture of an earlier modern era: 'To see this subordination as but a surface effect is not just to rethink modern architecture. It is also to displace the terms of political critique' (1995, 123).

However close the trompe of the fair-line surface-boundaries might come to this subordination, the context and dynamic of the situation— 'real-life seeing'—exposes the punter experiencing this illusion to the possibility of interruption. While both of these trompe set up specific, and at times overlapping or converging, modes of absorption, the particular surface effects set out along the fair-line are involved in more complex and multi-directional relations with an outside. The fair-line surface-boundary-limit operates effects in two directions, although it only has one side: like Teyssot's sock which closed the previous chapter, the experience it bounds can be turned inside or outside. 'One can inhabit the inwardness and one

may nurture its interiority, but only if it is understood as a surface, an exteriority that always comes between world and things' (Teyssot 2008, 12).[16] Irrespective of how difficult, futile even, it is to try and isolate a point of zero resolution in an encounter with the showfront, the principal and enduring difficulty is that when the latter is approached the surface effects so encountered address both inside and outside simultaneously. (This again contrasts to the surface of 'architectures of affect,' which refers the experience neither to a bounded inside nor an outside, but to an internalizing absorption within the surface itself.) Even with Bostock's priorities for the good frontage, there is still an outside, even though the generative logic of the fair-line demands that this can't be reached directly. Individually and collectively, the good frontage has an inside and an outside, although these have different surfaces and do not coincide. In contrast to the covert subordination that Wigley criticizes in other surface effects, or more pressingly, their denial, the active subordination that Bostock advocated was simultaneously both reinforced and undone by the contextual situation that includes adjacent showfronts and proximate intrusions such as neighbouring buildings. Offering a related counter-argument to architecture's prevailing dismissal of 'other' surfaces (those that don't conform to the modernist white wall or, by extension, to the 'Advanced Architecture of the Present'), Sam Jacob of FAT Architecture suggests architects are looking the wrong way: '"Taste not Space" [FAT's "ridiculous" slogan] argued that issues of "style", of "look" and so on—the things dismissed by architectural culture as frivolous and ephemeral—are actually the points where culture resides, the points where value and class are articulated and hence social and political content' (Jacob 2010, 83).[17] This is not to suggest now that the good frontages are architecture but simply to draw attention to the operation of these surfaces on their own terms and in their varied temporary contexts, as an example of a different, expanded and open attempt at 'subordination,' one that explicitly plays with social and cultural dynamics of surface production, communication and atmosphere. All through this book, when architectural theorists do stray into considerations of examples that are 'frivolous and ephemeral,' they qualify this interest by granting these moves 'exceptional' status. Carnivals, festivals, panoramas and stage sets, as well as casinos, the Strip and Main Street, are granted entry into architectural discussion with this 'exceptional' proviso, on the basis these are 'clearly' not (not expected to be) architecture. Al notes an occasion when the exception becomes accepted: 'The Strip began as an exception. But increasingly it has become a rule—in its holistically designed

and multisensory environments, in being technologically wired and "smart," in patterns of urban development, in financial practices, and in aesthetic tastes' (Al 2017, 219). Similarly perhaps, high-profile architectural involvement, big budget and high media exposure of the frivolous and ephemeral world's fairs and expos ease their entry into this discourse. Transfer from or normalization of the fairground is less simple, and the 'exceptional' operation of the good frontages is unlikely to become (accidentally) an architectural rule. Putting this the other way around, the good frontage has been broadly able to avoid assimilation into architectural discourse precisely thanks to its ephemeral character, consistent reinvention and pursuit of novelty in both surface and depth.

Reflecting also on the various limitations that inevitably accompany forays into the 'exceptional,' Andrew Benjamin's thinking on surfaces is arguably limited to design intention and effect. Avrum Stroll's work operates elsewhere, but limits its investigation of surface perception to that of the (given) subject's interaction with the (given) surface. In complementary ways, the contributions of Mark Wigley and Douglas Spencer provide a useful reminder that surfacing and division operate on the subject itself as much as on the surface (and depth) of the objects that surround it. In terms of the principal object of this study, Semper delimits surface discussion to that which falls within the *Stoffwechsel* lineage, granting an 'exception' to the illusory operation of the carnival or fairground surface. Attempts to unbound the lessons of Las Vegas and elsewhere were limited in advance by the general population's apparent failure to have even recognized, let alone assimilated, the superficial operations of these environments. In many ways, the delimitations of these studies, and the limitations they pass on to the present work, are commensurate with the complexities of the good frontages themselves. Like the hung canvas sailcloths from Faraday and Blouet's experiments, the show cloths and their descendants along the fair-line operate not by isolating the fair completely but by providing sufficient misinformation or distortion to the 'information' coming into the fair from the outside world that the latter's effects can be overcome—or at least temporarily be suppressed—by individual punters and crowds at the fair. The particular effect of such a doubling of information, rephrased according to one of Stroll's own general questions, is that the fair surface-boundary-limit defies any attempt to attain a 'point of zero resolution' where an observer can apprehend only the surface. In front of the good frontage, there is always interference, either from the materiality and decorative disposition of the surface itself, or from the active manipulation of 'normal'

spatial expectations that is carried out through the play of illusion, or from 'information' outwith the fairground. Clearly, this is not quite what the fair-line intends or invites us to do: Bostock's good frontage set out to provide a single surface effect that could harness the full attention of a fair-going crowd, a 'point of zero resolution' in Stroll's terms (balanced between magnification and resolution—a surface with no contextual depth or detail). For all its particular character and its admitted distance from most architectural production, the theoretical work of Stroll and Benjamin should encourage architects to take this more seriously rather than dismiss it (as did Semper and Ruskin) as an aberration, an exception.

NOTES

1. For a fuller account of the definition of A-Surfaces and P-Surfaces, see 'Two, Maybe Four, Conceptions of Surfaces' (Stroll 1988, 39–65). Coincidentally, the core thinking for what became *Learning from Las Vegas* was first published under the title 'A Significance for A&P Parking Lots' (Venturi and Scott Brown 1968).

2. Cache goes on to note: 'To appreciate Stroll's work and its relevance to architecture necessitates engaging with different conceptions of surface than that used in traditional architectural practice... The beauty of Stroll's text is that he privileges neither the outer cladding nor the inner substrate as primary—they are simply different parts of a nonhomogeneous entity' (2003, 32). However, Cache is incorrect to assert that Stroll is not inter-ested in perception (more than half of *Surfaces* is explicitly concerned with 'Surfaces and Perception,' as is much of his subsequent output—see Stroll 1992), and he is also incorrect to suggest Semper offers a simple reversal of surface and structure.

3. I am mindful that the ritual, liturgical and symbolic contexts of San Carlo are full of complexity and that the interior space of the church could be crowded with worshipers, but this does not colour Benjamin's analysis.

4. On the complexity of barkers and spielers, and the socio-cultural and tech-nological factors influencing the changing patter(n) in this front-of-house activity on the fairground, see Trowell (2018a).

5. As discussed in Chap. 5, much of Hartoonian's theoretical work draws from Gottfried Semper's discussion of what Hartoonian refers to as the 'tectonic of theatricality.'

6. It is also noteworthy that Böhme, like Hartoonian, also traces the distinc-tion between surface effect and materiality, between surface and structure, back to Semper: 'But of course the discrepancy between surface and inner structure that it epitomises has precursors reaching back far into the past:

not only related veneer techniques, but also architectural facings, stuccoed marble, enamelling. In fact the materialist Semper's own opera house is a prime example of the split between material and the staging of materiality, or materiality as theatre: the marble columns are stucco, the wooden panelling is painted' (Böhme [1995] 2013a, 96).

7. He names Christian Norberg-Shultz (1975) and Charles Jencks (1977) as representatives of these two approaches.

8. It should be stressed that Hays' essay is more broadly in sympathy with the line of architectural theory gathered here, moving from the dissolution of the object to the operative surface: 'where the disjunctive object once stood, there is now a new whole, a surface or field, that describes the space of propagation, the space of effects' (2001, 105).

9. Braithwaite's love of fairground architecture arguably colours his assertions here, which should consider more carefully the contemporary development of shop architecture, and that of the department store in particular.

10. In a curious aside that echoes the earlier discussion of the role or absence of the intellect in fairground fun, immediately after this passage Corb confesses: 'And on Broadway, divided by feelings of melancholy and lively gaiety, I wander along in a hopeless search for an intelligent burlesque show....'

11. Stefan Al describes various 'fakes' such as the Golden Nugget [1946] 'built in the 1850s San Francisco Barbary Coast style' complete with false opening date of 1905; William Moore's copying of a 'redwood Western church in California, dating back to the '49 Gold Rush days' (Moore was general manager of the *Last Frontier* Casino) (Al 2017, 13).

12. See also Esperdy (2008). This might also explain why campaigning, reactionary vitriol like Peter Blake's *God's Own Junkyard: The Planned Deterioration of America's Landscape*, (1964) also largely failed to take hold of the uncomprehending audience it addressed.

13. Jameson goes on to argue 'it is not even an exterior' (1991, 42). 'As Reinhold Martin has recently argued, there was... rhetorical profit to be found in the myriad reflections seen in this [Post Modern] style of architecture, which he prefers to read as de-flections: "The trick with mirrors and other real materials performed by corporate globalization produce the illusion that there is an illusion: the illusion that their materiality is illusory, unreal, dematerialized... This mode of distraction draws us in even as it keeps us out"' (Adamson 2013, 202, citing Martin (2010, 122)).

14. See also Zaera-Polo (2009, 114). Zaera-Polo makes explicit links between this practice and 'other *affect-driven* political forms' (2008, 199) by making reference to Nigel Thrift's influential work on *Non-Representational Theory: Space, Politics, Affect* (2007). Thrift himself is more circumspect about the contemporary interest in affect that he has in large part been

responsible for bringing about, noting elsewhere that 'the discovery of new means of practicing affect is also the discovery of a whole new means of manipulation by the powerful' (Thrift 2004, 58).

15. Adey covers a lot of ground, but in this section he is referring more directly to Brian Massumi, Giles Deleuze and Félix Guattari.

16. With a different clothing analogy, Victoria Kelly (2013) pushes the surface/depth binary she reads in the pocket as a reminder that this involves a relay between socio-cultural systems of meaning to phenomenological experience that combine in the relationship between surface and the experience of space. In particular, she contrasts the work of Mary Douglas and Gaston Bachelard.

17. FAT = Fashion Architecture Taste, a London-based architectural practice set up in 1995.

BIBLIOGRAPHY

Adamson, Glen. 2013. 'Substance Abuse: The Postmodern Surface.' In *Surface Tensions: Surface, Finish and the Meaning of Objects*, edited by Glenn Adamson and Victoria Kelley, 200–212. Manchester: Manchester University Press.

Adamson, Glenn and Victoria Kelley. 2013. *Surface Tensions: Surface, Finish and the Meaning of Objects*. Manchester: Manchester University Press.

Adey, Peter. 2008. 'Airports, Mobility and the Calculative Architecture of Affective Control.' *Geoforum*, 39 (1): 438–451.

Adorno, Theodor W. [1970] 1997. *Aesthetic Theory*. Translated by Robert Hullot-Kentor and Rolf Tiedemann. London: Athlone Press.

Anon. 1906. *The Showman*, August 31 1906.

Anon. 1908. *The World's Fair*, September 19 1908.

Anon. 1923. 'St Giles's Fair,' *Oxford Journal Illustrated*, Wednesday, September 5 1923.

Al, Stefan. 2017. *The Strip: Las Vegas and the Architecture of the American Dream*. Cambridge, MA: The MIT Press.

Anderson, Christy. 2002. *The Built Surface. Vol.1, Architecture and the Pictorial Arts from Antiquity to the Enlightenment*. Aldershot: Ashgate.

Aristotle. 1995. *Poetics*. Translated by Stephen Halliwell. Cambridge, MA: Harvard University Press.

Barker, Robert. 1787. 'Improvement on Painting.' *Edinburgh Evening Courant*, December 29 1787.

Batchelor, David. 2001. *Chromophobia*. London: Reaktion Books.

Benjamin, Andrew. 2006. 'Surface Effects: Borromini, Semper, Loos.' *The Journal of Architecture*, 11 (1): 1–36.

© The Author(s) 2018
S. Walker, *The Fair-Line and the Good Frontage*,
https://doi.org/10.1007/978-981-10-7974-0

Benjamin, Andrew. 2008. 'Plans to Matter: Towards a History of Material Possibility.' In *Material Matters*, edited by Katie Lloyd Thomas, 13–28. London: Routledge.

Benjamin, Andrew. 2015. *Art's Philosophical Work*. London: Rowman & Littlefield.

Benjamin, Walter. [1936] 1973. 'The Work of Art in the Age of Mechanical Reproduction.' In *Illuminations*, 211–244. Translated by Harry Zohn. London: Fontana Press.

Benjamin, Walter. 1982. *Das Passagen-Werk*, Vol. 1. Frankfurt: Suhrkamp. English edition. 2002. *The Arcades Project*. Translated by Howard Eiland and Kevin McLaughlin. Cambridge, MA: Harvard University Press.

Blake, Peter. 1964. *God's Own Junkyard: The Planned Deterioration of America's Landscape*. New York: Holt Rinehart Winston.

Böhme, Gernot. 1993. 'Atmosphere as the Fundamental Concept of a New Aesthetics.' Translated by David Roberts. *Thesis Eleven*, 36: 113–126.

Böhme, Gernot. [1995] 2013a. 'Staged Materiality.' *Interstices: Journal of Architecture and Related Arts*, 14 ('Immaterial Materialities'): 94–99. Previously published 1995. 'Staged Materiality', *Daidalos* (56): 36–43.

Böhme, Gernot. 2013b. 'The Art of the Stage Set as a Paradigm for an Aesthetics of Atmospheres.' *Ambiances*, 4. Posted online 10 February 2013, downloaded 13 September 2017. URL: http://ambiances.revues.org/315.

Böhme, Gernot. [2008] 2017. 'Atmospheres in Architecture.' In *Atmospheric Architectures: The Aesthetics of Felt Spaces*, 69–80. London: Bloomsbury.

Borden, Iain. 1997. 'Space Beyond: Spatiality and the City in the Writings of Georg Simmel,' *The Journal of Architecture*, 2 (4): 313–335.

Bostock, E. H. 1927. *Menageries, Circuses and Theatres*. London: Chapman & Hall.

Braithwaite, David. 1968. *Fairground Architecture*. London: Hugh Evelyn.

Braithwaite, David. 1975. *Savages of King's Lynn*. Cambridge: Patrick Stephens.

Braithwaite, David. 1976. *Travelling Fairs*. Aylesbury: Shire Publications.

Brigham, Ann. 2007. 'Behind-the-Scenes Spaces: Prompting Production in a Landscape of Consumption.' In *The Themed Space: Locating Culture, Nation, and Self*, edited by Scott A. Lukas, 207–223. Plymouth: Lexington.

Brown, Eric. 1945. 'Roundabouts: Demountable Baroque.' *The Architectural Review*, 578 (February): 49–60.

Buchanan, Peter. 1998. 'Musings About Atmosphere and Modernism' *Daidalos*, 68 (June): 80–9.

Bruno, Giuliana. 2014. *Surface: Matters of Aesthetics, Materiality, and Media*. Chicago: University of Chicago Press.

Cache, Bernard. 2002. 'Gottfried Semper: Stereotomy, Biology, and Geometry.' *Perspecta*, 33('Mining Autonomy'): 80–87.

Cache, Bernard. 2003. 'Philibert De L'Orme Pavillion: Towards an Associative Architecture.' In *Surface Consciousness*, edited by Mark Taylor, 21–35. London: Wiley.

Carter, Angela. 1982. 'Here Today, Gone Tomorrow.' Film essay with an intro-
duction by Melvyn Bragg (colour, 22mins, directed and produced by Bob
Bee). *The South Bank Show*, broadcast in the UK by ITV, 28 November 1982.

Carter, Angela. [1977] 1997. 'Fun Fairs.' In *Shaking a Leg: Journalism and
Writings*, 340–344. London: Chatto & Windus.

Chatterjee, Anuradha, ed. 2014. *Surface and Deep Histories: Critiques and
Practices in Art, Architecture and Design*. Newcastle: Cambridge Scholars.

Chestnova, Elena. 2016. 'The House that Semper Built.' *Architectural Theory
Review*, 21(1): 44–61.

Crary, Jonathan. 1990. *Techniques of the Observer: On Vision and Modernity in the
Nineteenth Century*. Cambridge, MA: MIT Press.

Crary, Jonathan. 2001. *Suspensions of Perception: Attention, Spectacle and Modern
Culture*. Cambridge, MA: MIT Press.

Crary, Jonathan. 2002. 'Géricault, the Panorama, and Sites of Reality in the Early
Nineteenth Century.' *Grey Room*, 9 (Fall): 5–25.

Cross, Gary S. and John K. Walton. 2005. *The Playful Crowd: Pleasure Places in
the Twentieth Century*. New York, NY: Chichester: Columbia University Press.

De Beaumont, Gustave and Alexis de Tocqueville. 1833. *On the Penitentiary
System in the United States and Its Application in France*. Translated by
E.K. Ferkaluk. London: Palgrave Macmillan.

De Cauter, Lieven. 1993. 'The Panoramic Ecstasy: On World Exhibitions and the
Disintegration of Experience.' *Theory, Culture & Society*, 10 (4): 1–23.

Deleuze, Giles and Félix Guattari. 1987. *A Thousand Plateaus: Capitalism and
Schizophrenia*. Translated by Brian Massumi. London: The Athlone Press.

Demetz, A. and A. Blouet. 1837. *Rapports sur les Pénitenciers des Etats-Unis*. Paris:
Imprimerie Royale.

Dorrian, Mark. 2014. 'Museum Atmospheres: Notes on Aura, Distance and
Affect.' *The Journal of Architecture*, 19 (2) ('City Air'): 187–201.

Dorrian, Mark. [2004] 2015. 'Cityscape with Ferris Wheel: Chicago 1893.' In
Writing on the Image: Architecture, the City and the Politics of Representation,
22–41. London: I. B. Tauris.

Dorrian, Mark. 2017. 'Ecstasies.' In *Atmospheric Architectures: The Aesthetics of
Felt Spaces*, edited by Gernot Böhme, xi–xii. London: Bloomsbury.

Dorrian, Mark and Frédéric Pousin, eds. 2013. *Seeing From Above: The Aerial
View in Visual Culture*. London: I. B. Tauris.

Edensor, Tim. 2012. 'Illuminated Atmospheres: Anticipating and Reproducing
the Flow of Affective Experience in Blackpool,' *Environment and Planning D:
Society and Space*, 30: 1103–1122.

Edensor, Tim and Steve Millington. 2013. 'Blackpool Illuminations: Revaluing
Local Cultural Production, Situated Creativity and Working-Class Values.'
International Journal of Cultural Policy, 19:2: 145–161.

Erdoes, Richard. 1979. *Saloons of the Old West*. New York: Knopf.

Esperdy, Gabrielle. 2008. *Modernizing Main Street: Architecture and Consumer Culture in the New Deal.* Chicago, IL: University of Chicago Press.

Esperdy, Gabrielle. 2014. 'Ugly America and Architecture on the Highway: A *Time-Life* View of the 1950s and 1960s.' In *Archi.Pop: Mediating Architecture in Popular Culture,* edited by D. Medina Lasansky, 177–189. London & New York: Bloomsbury Academic.

Evans, Robin. [1971] 1997. 'The Rights of Retreat and the Rites of Exclusion: Notes Towards the Definition of Wall.' In *Translations from Drawing to Building and Other Essays,* 195–231. London: AA Publications.

Evans, Robin. [1989] 1997. 'The Developed Surface: An Enquiry into the Brief Life of an Eighteenth-Century Drawing Technique.' In *Translations from Drawing to Building and Other Essays,* 34–53. London: AA Publications.

Faideau, F. 1900. 'Historiques des Exposition Universelles.' In *Encyclopédie du Siècle.* III: 313. Paris: Montgredin.

Ford, Andrew. 1995. 'Katharsis: The Ancient Problem.' In *Performativity and Performance,* edited by Andrew Parker and Eve Kosofsky Sedgwick, 109–132. London: Routledge.

Forty, Adrian. 1986. 'Hygiene and Cleanliness.' In *Objects of Desire,* 156–181. London: Thames and Hudson.

Frei, Hans. 2003. 'Masked Matter and Other Diagrams.' Translated by Claire Bonney. In *Surface Consciousness,* edited by Mark Taylor, 43–49. London: Wiley.

Frisby, David. 1986. *Fragments of Modernity.* Cambridge, MA: MIT Press.

Geppert. Alexander C. T. 2010. *Fleeting Cities: Imperial Expositions in Fin-de-Siècle Europe.* Basingstoke: Palgrave Macmillan.

Gibson, J. J. 1979. *The Ecological Approach to Visual Perception.* Boston, MA: Houghton.

Greville, Father. 1949. 'St. Giles Fair, Oxford.' *Merry-Go-Round,* VI (6) (*Special St. Giles' Fair Edition.* August): 4–7.

Gorman, John. 1976. *Banner Bright: An Illustrated History of the Banners of the British Trade Union Movement.* Harmondsworth, Middlesex: Penguin Group.

Greenhalgh, Paul. 2011. *Fair World: A History of World's Fairs and Expositions, from London to Shanghai, 1851–2010.* Winterbourne, Berkshire, UK: Papadakis.

Grau, Oliver. 1999. 'The Panorama: History of a Mass Medium.' *Leonardo,* 21 (2): 143–144.

Hartoonian, Gevork. 2006. *Crisis of the Object: The Architecture of Theatricality.* London: Routledge.

Hartoonian, Gevork. 2012. *Architecture and Spectacle: A Critique.* Farnham: Ashgate.

Hatton, Brian. 1999. 'The Problem of Our Walls.' *The Journal of Architecture,* 4 (1): 65–80.

Hays, K. Michael. 2001. 'Prolegomenon for a Study Linking the Advanced Architecture of the Present to that of the 1970s Through Ideologies of Media, the Experience of Cities in Transition, and the Ongoing Effects of Reification'. *Perspecta*, 32: 100–107.

Hellman, Louis. 1998. 'Who Said What.' *The Architects Journal*, July 16 1998.

Hernández Barbosa, Sonsoles. 2017. 'Beyond the Visual: Panoramatic Attractions in the 1900 World's Fair.' Translated by David Govantes Edwards. *Visual Studies*, 1–12. https://doi.org/10.1080/1472586X.2017.1288071

Hirschfeld, C. C. L. 1779–1785. *Theorie der Gartenkunst*. Leipzig: Weidmanns Erben und Reich.

Howell, Alan S. 2003. *Men at Work: The Fairground Artists and Artisans of Orton & Spooner*. St. Albans, Herts: Skelter Publishing.

Hugo, Victor. [1831] 2002. *The Hunchback of Notre Dame*. Translated by Catherine Liu. New York: Random House.

Huhtamo, E. 2012. *Illusions in Motion. Media Archaeology of the Moving Panorama and Related Spectacles*. Cambridge, MA: The MIT Press

Jacob, Sam. 2010. 'Surface as Manifesto,' In *The Articulate Surface: Ornament and Technology in Contemporary Architecture*, edited by Ben Pell, 83. Basel: Birkhäuser.

Jameson, Fredric. 1991. *Postmodernism: Or, The Cultural Logic of Late Capitalism*. London: Verso.

Jay, Martin. 1993. *Downcast Eyes: The Denigration of Vision in Twentieth-Century French Thought*. Berkeley, CA: University of California Press.

Jencks, Charles. 1977. *The Language of Postmodern Architecture*. London: Academy Editions.

Jones, Barbara. 1951. *The Unsophisticated Arts*. London: Architectural Press.

Jones, Owen. 1859. *The Grammar of Ornament*. London: Day & Son Ltd

Kane, Josephine. 2013. *The Architecture of Pleasure: British Amusement Parks 1900–1939*. London: Ashgate.

Kaufmann, Emile. 1955. *Architecture in the Age of Reason: Baroque and Post-Baroque in England, Italy, and France*. Cambridge, MA: Harvard University Press.

Kelly, Victoria. 2013. 'A Superficial Guide to the Deeper Meanings of Surface.' In *Surface Tensions: Surface, Finish and the Meaning of Objects*, edited by Adamson Glenn and Victoria Kelley, 13–25 Manchester & New York: Manchester University Press.

Koehler, Karen. 2002. *The Built Surface. Vol.2, Architecture and the Pictorial Arts from Romanticism to the Twenty-First Century*. Aldershot: Ashgate.

Kulper, Amy Catania and Diana Periton. 2015. 'Urban Atmospheres: An Introduction.' *Architecture and Culture*, 3 (2) (July): 121–126.

Ind, Rosemary. 1976. 'The Architecture of Pleasure: Joseph Emberton's Work at Blackpool, 1933–1939.' *Architectural Association Quarterly*, 8 (3): 51–59.

Ind, Rosemary. 1983. *Emberton*. London: Scholar.

LaBelle, Brandon. 2010. *Acoustic Territories: Sound Culture and Everyday Life.* New York & London: Continuum.

Levine, Caroline. 1998. 'Seductive Reflexivity: Ruskin's Dreaded Trompe l'oeil', *The Journal of Aesthetics and Art Criticism*, 56 (4) (Autumn): 366–375.

Le Corbusier. [1925] 1987. 'A Coat of Whitewash: The Law of Ripolin.' In *The Decorative Art of Today*, 185–192. Translated by James I. Dunnett. London: The Architectural Press.

Le Corbusier. [1937] 1964. *When the Cathedrals Were White*. Translated by Francis E. Hyslop. New York: McGraw-Hill Book Company.

Leatherbarrow, David and Mohsen Mostafavi. 2002. *Surface Architecture.* Cambridge, MA: MIT Press.

Lehmann, Ulrich. 2013. 'Surface as Material, Material into Surface: Dialectic in Carol Christian Poell.' In Adamson, Glenn and Victoria Kelley, *Surface Tensions: Surface, Finish and the Meaning of Objects*, 147–163. Manchester & New York: Manchester University Press.

Logan, Roger. 2012. *From East Riding to East End: A Life of George Tutill— Regalia Manufacturer.* http://www.flags-tutill.co.uk/pdf/George-Tutill-Monograph.pdf. Accessed on May 3 2016.

Loos, Adolf. [1908] 1985. 'Ornament and Crime' In *The Architecture of Adolf Loos*, 100–103. London: The Arts Council.

Lupton, Ellen, ed. 2002. *Skin, Surface, Substance and Design.* Princeton, NJ: Princeton Architectural Press.

Mallgrave, Harry Francis. 1996. *Gottfried Semper: Architect of the Nineteenth Century.* New Haven & London: Yale University Press.

Mallgrave, Harry Francis. 2004. 'Introduction.' In *Style in the Technical and Tectonic Arts: Or, Practical Aesthetics,* edited by Gottfried Semper and Translated by Harry Francis Mallgrave and Michael Robinson, 1–67. LA Getty Publications.

Martin, Reinhold. 2010. *Utopia's Ghost: Architecture and Postmodernism, Again.* Minneapolis: University of Minnesota Press.

Martin, Reinhold. 2016. 'Unfolded, Not Opened: On Bernhard Siegert's *Cultural Techniques*'. *Grey Room*, 62 (Winter): 102–115.

Miller, Naomi. 1982. *Heavenly Caves: Reflections on the Garden Grotto.* Boston, London, Sydney: George Allen & Unwin.

Morley, Henry. 1859. *Memoirs of Bartholomew Fair.* London: Chapman Hall.

Muncey, Raymond Waterville Luke. 1936. *Our Old English Fairs.* London: Sheldon Press.

Murphy, Thomas. 1940. *History of the Showmen's Guild / Pt.1, 1889–1939.* London: Showmen's Guild of Great Britain and Ireland.

Murphy, Thomas. n.d., c.1950. *Continuation of the History of the Showmen's Guild.* London: Showmen's Guild of Great Britain and Ireland.

Nelson, Steve. 1986. 'Walt Disney's EPCOT and the World's Fair Performance Tradition.' *Tulane Drama Review*, 30 (4): 106–146.

Neumeyer, Fritz. 1999. 'Head First Through the Wall: An Approach to the Non-Word Façade.' *The Journal of Architecture*, 4 (3) (Autumn): 245–259.

Norberg-Shultz, Christian 1975. *Meaning in Western Architecture*, New York: Praeger Publishers.

Oettermann, Stephan. 1997. *The Panorama: History of a Mass Medium*. Translated by Deborah Lucas Schneider. New York: Zone Books.

Pell, Ben. 2010. *The Articulate Surface: Ornament and Technology in Contemporary Architecture*. Basel: Birkhäuser.

Pelletier, Louise. 2006. *Architecture in Words: Theatre, Language and the Sensuous Space of Architecture*. London: Routledge.

Picon, Antoine. 2013. *Ornament: The Politics of Architecture and Subjectivity*. London: AD Primers, Wiley.

Plotz, John. 2006. 'The Return of the Blob, or How Sociology Decided to Stop Worrying and Love the Crowd.' In *Crowds*, edited by Jeffrey T. Schnapp and Matthew Tiews, 203–223. Stanford, CA: Stanford University Press.

Rainsley, Neville H. 1946. 'Those Were the Days! A Retrospect. (Part I).' *Merry-Go-Round*, V (11): 28.

Redecke, Sebastian. 2013. 'Wir wollen keine Kirmes veranstalten.' ['We Don't Want to Organise Some Kind of Fairground']. *Bauwelt*, 104 (9) (March): 6–8.

Redner, Harry. 1994. *A New Science of Representation: Towards an Integrated Theory of Representation in Science, Politics, and Art*. Boulder, CO: Westview Press.

Robbe-Grillet, Alain. [1963] 1965. *For a New Novel*. Translated by Richard Howard. New York: Grove.

Ross, Kristin. 1994. *Fast Cars, Clean Bodies: Decolonization and the Reordering of French Culture*. Cambridge, MA: MIT Press.

Ruskin, John. [1843] 1903. 'Modern Painters'. In *The Works of John Ruskin*, edited by E.T. Cook & Alexander Wedderburn, Vol. III, 77–634. London: George Allen.

Ruskin, John. [1878] 1908. 'Letter to Mr. Freshfield, Undated, But Written About the End of the Year 1878.' In *The Works of John Ruskin*, edited by C. T. Cook & Alexander Wedderburn, Vol. 26, 567. London: George Allen.

Ruskin, John. [1885–89] 1908. 'Praeterita'. In *The Works of John Ruskin*, edited by C. T. Cook & Alexander Wedderburn, Vol. 35, 137, 117. London: George Allen.

Schnapp, Jeffrey T. 2006. 'Mob Porn.' In *Crowds*, edited by Jeffrey T. Schnapp and Matthew Tiews, 1–45. Stanford, CA: Stanford University Press.

Semper, Gottfried. [1851] 1989. 'The Four Elements of Architecture: A Contribution to the Comparative Study of Architecture'. In *The Four Elements of Architecture and Other Writings*, 74–129. Translated by Harry Francis Mallgrave and Wolfgang Herrmann. Cambridge: Cambridge University Press.

Semper, Gottfried. [1860–63] 1989. 'Style in the Technical and Tectonic Arts: Or, Practical Aesthetics: The Textile Art (Excerpt).' In *The Four Elements of Architecture and Other Writings*, 215–263. Translated by Harry Francis Mallgrave and Wolfgang Herrmann. Cambridge: Cambridge University Press.

Semper, Gottfried. [1860–63] 2004. *Style in the Technical and Tectonic Arts: Or, Practical Aesthetics*. Translated by Harry Francis Mallgrave and Michael Robinson. Los Angeles: Getty Publications.

Sloterdijk, Peter. 2013. *In the World Interior of Capital: Towards a Philosophical Theory of Globalization*. Translated by Wieland Hoban. Cambridge: Polity Press.

Spencer, Douglas. 2016. *The Architecture of Neoliberalism: How Contemporary Architecture Became an Instrument of Control and Compliance*. London: Bloomsbury Academic.

Spuybroek, Lars. 2011. *The Sympathy of Things: Ruskin and the Ecology of Design*. Rotterdam: V2 Publishing/NAi Publishing.

Stallybrass, Peter and Allon White. 1986. *The Politics and Poetics of Transgression*. London: Methuen.

Stroll, Avrum. 1988. *Surfaces*. Minneapolis: University of Minnesota Press.

Stroll, Avrum. 1992. 'Reflections on Surfaces.' *Canadian Journal of Philosophy*, 22 (2, June): 191–210.

Taylor, David. 1999. 'Heritage Boss in Row Over Alsop's London HQ Design.' *The Architects Journal*, 209 (3) (January 21 1999): 7.

Teyssot, Georges. 2008. 'Mapping the Threshold: A Theory of Design and Interface.' *AA Files*, 57: 3–12.

Thrift, Nigel. 2004. 'Intensities of Feeling.' *Geografiska Annaler* (Series B: Human Geography), 86 (1): 57–72.

Thrift, Nigel. 2007. *Non-Representational Theory: Space, Politics, Affect*. London: Routledge.

Trachana, Angelica. 1998. 'Astralago.' *Independent on Sunday*, July 12 1998.

Trowell, I. 2016. 'Collision, Collusion and Coincidence: Pop Art's Fairground Parallel.' *Visual Culture in Britain*, 17(3): 329–350.

Trowell, Ian. 2017a. 'Atmosphere Creator: The Sounds of the Fairground.' In *Listening to Music: People, Practices and Experiences*, edited by Helen Barlow and David Rowland. Milton Keynes: Open University. Open access publication at http://ledbooks.org/proceedings2017/

Trowell, Ian. 2017b. 'Contemporary Photographic Practices on the British Fairground.' *Photographies*, 10 (2): 211–231.

Trowell, Ian. 2018a. 'Spiel, Patter or Sound Effect: Tracking the Residual Voice on the Travelling Fun-Fair.' *Journal of Interdisciplinary Voice Studies*, forthcoming.

Trowell, Ian. 2018b. 'Only One Can Rule the Night: Fairs and Music in Post-1945 Britain.' *Popular Music History*, forthcoming

Toulmin, Vanessa. 2003. *Pleasurelands*. Sheffield: NFA Sheffield, in association with The Projection Box, Hastings.

Van Doesburg, Theo. 1929. 'Farben in Raum und Zeit.' *De Stijl* (87, 88, 89): 26–36.

Venturi, Robert and Denise Scott Brown. 1968. 'A Significance for A&P Parking Lots.' *Architectural Forum*, 128 (2) (March): 37–43.

Venturi, Robert, Denise Scott Brown and Steven Izenour. 1977. *Learning From Las Vegas*, Cambridge, MA: MIT Press.

Vidler, Antony. 1987. *The Writing of the Walls: Architectural Theory in the Late Enlightenment*. Princeton, NJ: Princeton Architectural Press.

Vidler, Antony. 2000. 'Spaces of Passage: The Architecture of Estrangement: Simmel, Kraucuer, Benjamin.' In *Warped Space: Art, Architecture, and Anxiety in Modern Culture*, 64–79. Cambridge, MA: MIT Press.

Walker, Stephen. 2015. 'Illusory Objects and Fairground Architecture.' *The Journal of Architecture*, 20 (2) (April): 309–354.

Weedle, Robert. 2008. 'Sound, Light, and the Mystique of Space: Paris 1937.' In *Festival Architecture*, edited by Sarah Bonnemaison and Christine Macy, 215–237. London: Routledge.

Weedon, Geoff and Richard Ward. 1981. *Fairground Art*. London: White Mouse (in association with New Cavendish Books).

Wigley, Mark. 1995. *White Walls, Designer Dresses: The Fashioning of Modern Architecture*. Cambridge, MA: MIT Press.

Wigley, Mark. 1998. 'The Architecture of Atmosphere.' *Daidalos*, 68 (June): 18–27.

Wigley, Mark. 2000. 'The Architectural Cult of Synchronisation.' *October*, 94 (Fall): 31–61.

Wilcox, Scott B. 1988. 'Unlimiting the Bounds of Painting.' In Ralph Hyde. *Panoramania!: The Art and Entertainment of the 'All-Embracing' View*, 13–44. London: Trefoil (in association with the Barbican Art Gallery).

Zaera-Polo, Alejandro. 2008. 'The Politics of The Envelope.' *Log* 13/14 (*Aftershocks: Generation(s) since 1968*) (Fall): 193–207.

Zaera-Polo, Alejandro. 2009. 'The Politics of The Envelope, Part II.' *Log*, 16 (Spring/Summer): 97–132.

Index[1]

[1] Note: Page numbers followed by 'n' refer to notes.

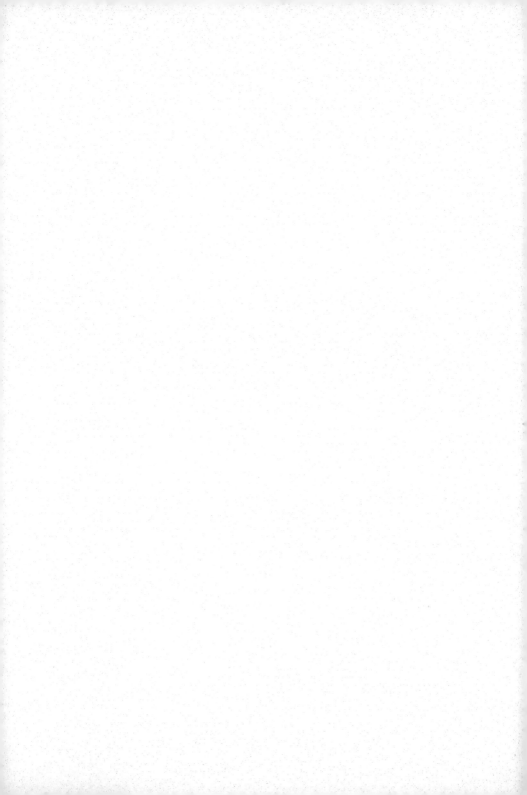

Printed by Printforce, the Netherlands